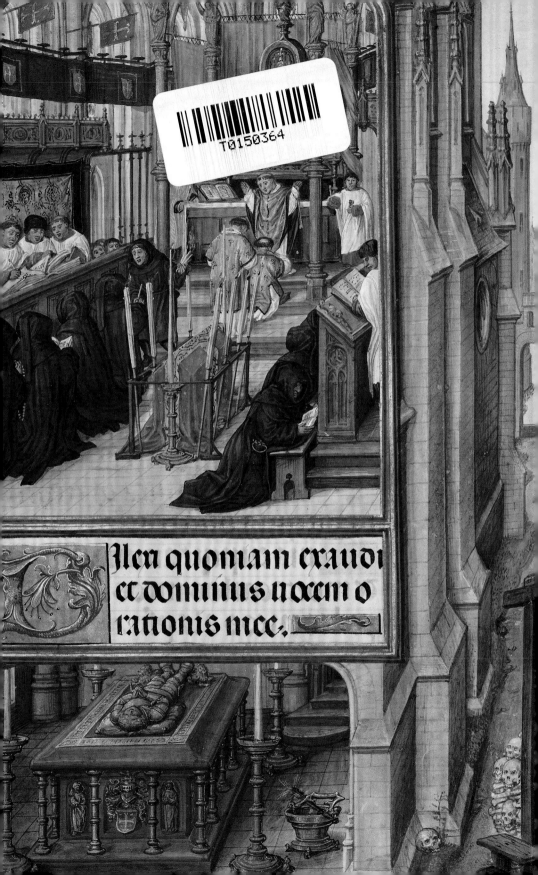

T0150364

UNDERSTANDING

Illuminated Manuscripts

A GUIDE TO TECHNICAL TERMS

REVISED EDITION

MICHELLE P. BROWN

Revised by ELIZABETH C. TEVIOTDALE and NANCY K. TURNER

THE J. PAUL GETTY MUSEUM | LOS ANGELES

© 2018 J. Paul Getty Trust
© 1994 J. Paul Getty Trust and The British Library Board
First edition 1994
Second edition 2018

Published by the J. Paul Getty Museum, Los Angeles
Getty Publications
1200 Getty Center Drive, Suite 500
Los Angeles, California 90049-1682
www.getty.edu/publications

Rachel Barth, *Project Editor*
Ann Hofstra Grogg, *Manuscript Editor*
Kurt Hauser, *Designer*
Amita Molloy, *Production*

Distributed in the United States and Canada by the University of Chicago Press
Distributed outside the United States and Canada by Yale University Press, London

Printed in China

Library of Congress Cataloging-in-Publication Data
Names: Brown, Michelle (Michelle P.), author. | Teviotdale, Elizabeth C.
 (Elizabeth Cover), 1955– editor. | Turner, Nancy, 1960– editor. | J. Paul
 Getty Museum, issuing body.
Title: Understanding illuminated manuscripts : a guide to technical terms /
 Michelle P. Brown ; revised by Elizabeth C. Teviotdale and Nancy K. Turner.
Other titles: Looking at.
Description: Second edition. | Los Angeles : J. Paul Getty Museum, [2018] |
 Series: Looking at | Includes bibliographical references.
Identifiers: LCCN 2018015403 | ISBN 9781606065785 (pbk.)
Subjects: LCSH: Illumination of books and manuscripts—Dictionaries.
Classification: LCC ND2889 .B76 2018 | DDC 745.6/703—dc23
LC record available at https://lccn.loc.gov/2018015403

Front cover: Simon Bening, *The King of Arms of the Golden Fleece Writing about Jacques de Lalaing*. In *Livre des faits de Jacques de Lalaing*, ca. 1530 (detail, p. 7)

Page i: Master of James IV of Scotland, *Office of the Dead*. In a book of hours known as the Spinola Hours, ca. 1510–20 (detail, p. 58)

Page ii: Inhabited initial *D*. In a missal known as the Stammheim Missal, ca. 1170s (detail, p. 59)

Illustration Credits
Every effort has been made to contact the owners and photographers of objects reproduced here whose names do not appear in the captions or in the illustration credits listed below. Anyone having further information concerning copyright holders is asked to contact Getty Publications so this information can be included in future printings.

Pages 25, 47, 67 (above): © 2017 Western Michigan University, Kalamazoo, Michigan, all rights reserved

Page 54: By permission of the British Library, Ms. Egerton 747, fol. 16v / British Library / GRANGER

Page 69: By permission of the British Library, Ms. Arundel 251, fol. 46 / British Library / GRANGER

Pages 73 (right), 116 (below): Getty Conservation Institute

Page 93: By permission of the British Library, Ms. Royal 14 B vi, Membrane 5 / British Library / GRANGER

Page 112: HM 47641, f. 5, The Huntington Library, San Marino, California

Foreword to the First Edition

This guide is designed to provide information for the public, students, and professionals alike about the history of manuscript production and its study: the contexts of production and the people involved (contained in entries such as SCRIBE, ILLUMINATOR, MASTER, WORKSHOP, STATIONER, PATRON, SCRIPTORIUM, MONASTIC PRODUCTION, and SECULAR PRODUCTION); the physical processes and techniques employed (CODICOLOGY); the types of text encountered (from liturgical volumes used in the performance of the MASS and DIVINE OFFICE and others, such as the BOOK OF HOURS, made for private devotions, to CLASSICAL and MEDICAL TEXTS as well as the ROMANCES and APOCALYPSES commissioned by secular patrons); and the terminology applied to the elements, styles, and forms of ILLUMINATION.

Understanding Illuminated Manuscripts covers works made in the West from Antiquity until the early modern period and the establishment of printing, but reference is also made to later periods when relevant. The manuscript production of non-Western cultures could not be included, since such subjects as Hebrew and Islamic manuscripts are complex fields in their own right. However, important influences of non-Western cultures on the production of manuscripts in the West are cited in various entries.

I should like to thank the following for their invaluable advice and assistance on this project: the staff of the manuscripts department and the photographic, publication, and design offices of the J. Paul Getty Museum and the British Library, especially Thomas Kren, Janet Backhouse, John Harris, Kurt Hauser, Elizabeth Teviotdale, Jane Carr, David Way, Peter Kidd, Erik Inglis, and Nancy Turner; as well as Linda Brownrigg, Philip Lewis, Sheila Schwartz, and Patricia Stirnemann. I should also like to acknowledge a particular debt of gratitude to William Noel for his unstinting assistance and friendship and to my husband, Cecil Brown, for his understanding and support during this endeavor, as ever.

M. P. B.

Preface

Nearly twenty-five years have passed since the original edition of *Understanding Illuminated Manuscripts* was published. The book has thrived during those years, having been reprinted many times. Nevertheless, the time has come to refresh its text and its illustrations, and this revised edition is intended as an update. It features an entirely new series of images, nearly all drawn from the J. Paul Getty Museum's rich collection of illuminated manuscripts. In choosing the images, we have focused on the terms we thought would most benefit from illustration, and we hope that the result enhances the pedagogical value of the volume. We have introduced new entries on the terminology associated with the most common types of technical analysis of manuscripts, an area of study that has burgeoned in the years since the publication of the original edition. We have also updated the text to reflect new scholarship and to conform to more current usage.

In working on this revision, we have benefited from the advice and help of many. Elizabeth Teviotdale would like to thank especially Elizabeth Morrison, senior curator of manuscripts at the J. Paul Getty Museum, for her inspiration and sage advice, and Ramsay Teviotdale and Raymond Clemens for their thoughtful critiques of the text. Nancy Turner would like to thank Karen Trentelman, senior scientist, and Catherine Patterson, associate scientist, in the Getty Conservation Institute's Collections Research Laboratory for their helpful input on the descriptions of scientific analytical methods and the complementary images. We thank Ann Hofstra Grogg for her many editorial improvements; Katherine Sedovic for her help assembling image captions; Kayla Kee, with the assistance of Johana Herrera and Alexandra Kaczenski, for providing new photography; Kurt Hauser for the book's updated design; Amita Molloy for managing the book's production; Nina Damavandi for her assistance with rights and permissions; and Dianne Woo for her careful proofreading. We especially thank Kara Kirk, Karen Levine, and Rachel Barth for their support in championing the reissue of this publication.

E. C. T. *&* N. K. T.

External Binding Structure

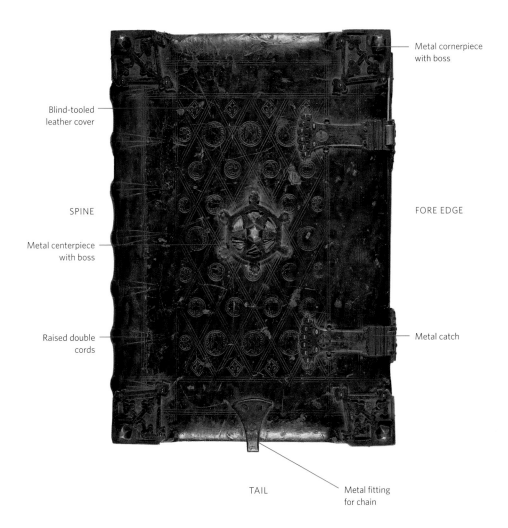

Metal cornerpiece
with boss

Blind-tooled
leather cover

SPINE

FORE EDGE

Metal centerpiece
with boss

Raised double
cords

Metal catch

TAIL

Metal fitting
for chain

EXTERNAL BINDING STRUCTURE
Front cover. Bible, Cologne, ca. 1450. 36.7 × 26 cm (14⁷⁄₁₆ × 10¼ in.). Los Angeles,
JPGM, Ms. Ludwig I 13 (83.MA.62)

Internal Binding Structure

HEAD

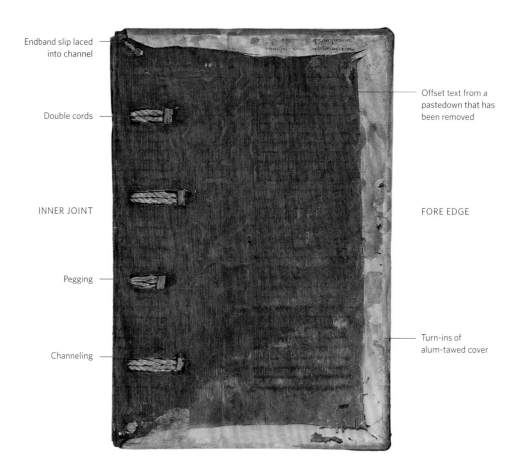

Endband slip laced into channel

Offset text from a pastedown that has been removed

Double cords

INNER JOINT

FORE EDGE

Pegging

Channeling

Turn-ins of alum-tawed cover

TAIL

Internal binding structure
Inside back cover. Vincent de Beauvais, *Opuscula*, Switzerland, 1481. 21.6 × 30.3 cm (8½ × 11¹⁵⁄₁₆ in.). Los Angeles, JPGM, Ms. PR.BK.2 (2011.42)

Elements of Illumination

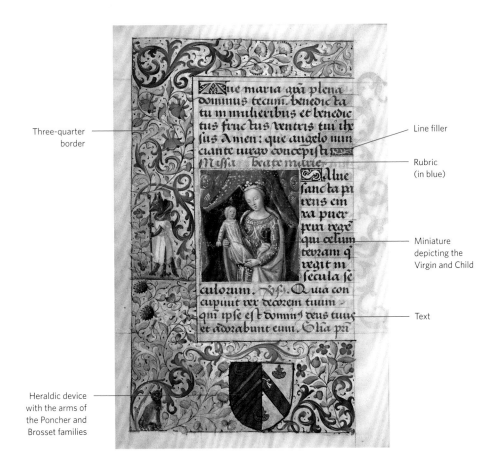

Three-quarter border

Heraldic device with the arms of the Poncher and Brosset families

Line filler

Rubric (in blue)

Miniature depicting the Virgin and Child

Text

ELEMENTS OF ILLUMINATION
Master of the *Chronique scandaleuse, Virgin and Child*. In a book of hours known as the Poncher Hours, Paris, ca. 1500. 13.3 × 8.7 cm (5¼ × 3⁷⁄₁₆ in.). Los Angeles, JPGM, Ms. 109 (2011.40), fol. 90v

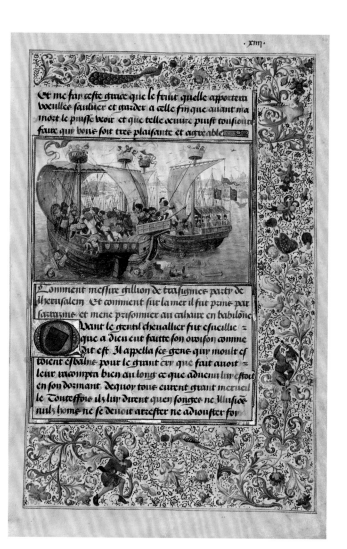

ACANTHUS

Lieven van Lathem,
*Gillion's Ship Attacked by
the Sultan's Army*. In *Roman
de Gillion de Trazegnies*,
Antwerp, after 1464. 37 ×
25.5 cm (14⁹/16 × 10¹/16 in.).
Los Angeles, JPGM, Ms.
111 (2013.46), fol. 21 and
detail

Glossary

ABBREVIATION

Abbreviations were often used in MANUSCRIPTS to save space and effort when writing. They generally fall into three categories: *suspensions*, in which the end or an internal syllable of a word is abbreviated, signaled by the use of a horizontal bar or another graphic symbol; *contractions*, a suspension or series of suspensions in which the first and last letters of the word are present; and *analphabetic abbreviations*, generally used for whole words and often derived from the tachygraphic (shorthand) systems of ANTIQUITY (that of Tiro, Cicero's secretary, being most influential). All three types of abbreviation could be and generally were used in the same manuscript.

During Antiquity a few common elements were often abbreviated (notably the Latin word endings *-bus* and *-que* and the final *m* and *n*). Abbreviations for *nomina sacra* ("sacred names"), such as the *xp̄s* form of *Christus* (see CHI-RHO), were used throughout the Middle Ages. INSULAR scribes were especially fond of abbreviations, including Tironian *notae*, and Irish scribes used them extensively in order to produce pocket-size GOSPEL BOOKS. With the growth of universities around 1200, the use of abbreviations proliferated. Medieval readers would have been familiar with most conventions of abbreviation, although there were probably always some abbreviated words that were particularly obscure, and there is evidence that SCRIBES themselves sometimes puzzled over certain abbreviations.

ACANTHUS

A foliate motif much used in medieval art and derived from the depiction of the acanthus plant in a decorative context in ANTIQUITY. Medieval renditions of the acanthus are generally not as true to the actual plant as those of Antiquity, reducing it to STYLIZED fleshy fronds, often brightly colored. Acanthus ornament was particularly favored by the CAROLINGIANS.

ALLEGORY

A symbolic depiction of an idea. For example, the vagaries of fortune might be symbolized visually by a female figure, Fortuna, turning a wheel upon which figures from varied walks of life rise and fall.

ALUM-TAWED SKIN

A dehaired animal skin that has been soaked in potash alum (potassium aluminum sulfate) to produce a strong, supple white material that was frequently used in medieval bookbindings as sewing supports (THONGS), fore-edge straps, and a covering material. When dampened, alum-tawed skin darkens slightly and becomes quite stiff, as it is less resistant than leather to the effects of moisture (see the illustration accompanying STRAP AND PIN). Alum-tawed skins are not considered leather because of the different chemical processes involved in their manufacture (leather being TANNED). Called *whittawers*, medieval makers of alum-tawed skins were separate and distinct from tanners.

ANGLO-SAXON
Christ Teaching. Detached leaf from a Gospel book, Canterbury, ca. 1000. 22.1 × 20 cm (8¹¹⁄₁₆ × 7⅞ in.). Los Angeles, JPGM, Ms. 9 (85.MS.79), leaf 2v

ANGLO-SAXON

Of or pertaining to the period of the history of England extended from ca. 500 to 1066. During this time, England was largely settled and ruled by GERMANIC peoples, primarily the Angles and the Saxons. Prior to the Viking incursions of the ninth century, the culture of England interacted closely with that of CELTIC Britain and Ireland. The art produced during the period from ca. 550 to 900 is often termed INSULAR, reflecting this interaction among the peoples inhabiting the regions now known as the British Isles.

In the tenth century, two major Anglo-Saxon painting styles developed, largely under the influence of Insular and CAROLINGIAN models. The first, or *Winchester*, style is so named because some of its most famous examples were probably made at Winchester, even though the style was diffused throughout the region. It is characterized by an opulent manner of painting, with rich colors and GILDING (unless executed in a TINTED or OUTLINE DRAWING style); a NATURALISTIC figure style; fluttering, decorative drapery; and a heavy ACANTHUS ornament. This style exhibits the influence of Carolingian art, specifically the Court School of Charlemagne, the School of Metz, and the Franco-Saxon School (which employed INTERLACE motifs ultimately

of Insular inspiration). The second major style, the *Utrecht* style, was inspired by the Utrecht PSALTER, a Carolingian manuscript known in Anglo-Saxon England that featured an agitated, sketchy, and ILLUSIONISTIC form of outline drawing adapted from classical painting technique. During the first half of the eleventh century, the Winchester and Utrecht styles began to fuse. Scandinavian art also exerted a limited influence during the Anglo-Saxon period.

ANTHROPOMORPHIC INITIAL

An INITIAL composed wholly or partly of a human figure or human figures. Anthropomorphic motifs occur in other decorative contexts as well. See the illustration accompanying PRICKING.

ANTIPHONAL

A book containing the sung portions of the DIVINE OFFICE, also called *antiphoner* or *antiphonary*. Antiphonals are often large in format so that they could be used by a choir, and include DECORATED and HISTORIATED INITIALS depicting saints and key events of the liturgical year. Hymns are usually contained in a separate volume. The contents of the antiphonal are generally arranged in accordance with the TEMPORALE, SANCTORALE, and COMMON OF SAINTS in liturgical order.

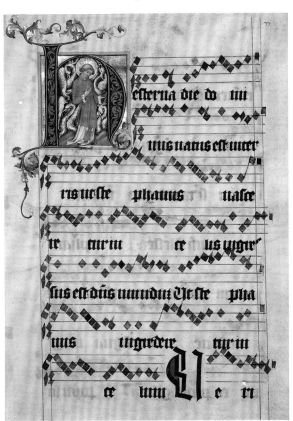

ANTIPHONAL
Circle of the Master of the Golden Bull, initial *H: Saint Stephen*. Detached leaf from an antiphonal, Prague, ca. 1405. 56.5 × 39.7 cm (22¼ × 15⅝ in.). Los Angeles, JPGM, Ms. 97 (2005.33), leaf 1

ANTIQUITY

The classical world of Greece and Rome, prior to the decline of the Roman Empire in the fifth century and the settlement of much of the western half of its former territory by barbarian peoples. Some of the peoples who came to inhabit the former western Empire, notably the Ostrogoths and the Visigoths, were more inclined than others to promote continuity with the culture of Roman antiquity. The BYZANTINE Empire became the cultural and political heir to much of what had been the eastern part of the Roman Empire.

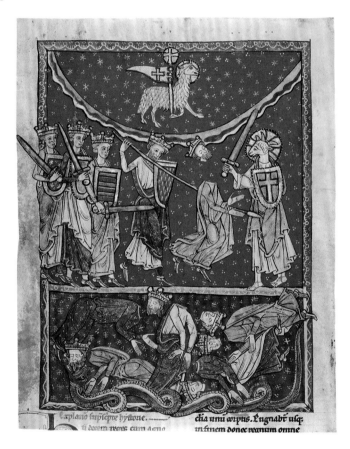

APOCALYPSE
The Lamb Defeating the Ten Kings. Detached leaf from Beatus of Liébana, *Commentarius in Apocalypsim*, northern Spain, ca. 1220–35. 29.4 × 23.5 cm (11⁹/₁₆ × 9¼ in.). Los Angeles, JPGM, Ms. 77 (2003.103), recto

APOCALYPSE

The biblical book describing Saint John the Divine's vision of events at the end of time, known in the Protestant tradition as the Book of Revelation. During the Middle Ages, Apocalypse manuscripts were produced in Latin and VERNACULAR versions often accompanied by COMMENTARIES, such as that of Berengaudus, and often with PICTURE CYCLES of varying length, style, and technique.

Apocalypse manuscripts were particularly popular in tenth- and eleventh-century Spain, where the scriptural text was integrated with the commentary of Beatus of Liébana (ca. 776) and produced in lavishly illustrated copies over the course of centuries. They were also popular in England (ca. 1250–1400), with production probably

centered in London. Apocalypse manuscripts proliferated during the thirteenth century, possibly due to escalating fears concerning the Antichrist (associated by many with the Holy Roman emperor Frederick II, 1194–1250).

ARABESQUE

An ornament or style of ornamentation consisting of fine curving lines characteristic of Islamic art.

ARABIC NUMERALS

The figures 0–9, introduced into Europe from India, via the Islamic world, around 1100. From the thirteenth century on, the use of Arabic numerals increased, partially supplanting ROMAN NUMERALS and other alphabetic systems of numeric representation. They did not come into pervasive use, however, until the fifteenth century.

ASTRONOMICAL/ASTROLOGICAL TEXTS

Manuscripts on the subject of astronomy and astrology often contain images associated with the constellations (such as Orion the hunter and Aquarius the water bearer) and diagrammatic representations of the universe and its components. Some of the

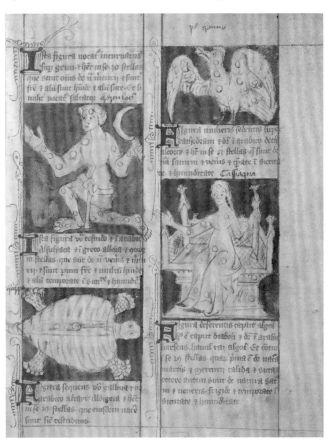

ASTRONOMICAL/
ASTROLOGICAL TEXTS
Constellations. In
*Astronomical and Medical
Miscellany: Toledan
Constellation Tables,*
England, after 1386. 21.3 ×
15.2 cm (8⅜ × 6 in.).
Los Angeles, JPGM, Ms.
Ludwig XII 7 (83.MO.136),
fol. 2

major astronomical texts appearing in illuminated copies include Cicero's *Aratea*, written in the first century BCE, a Latin translation of a third-century BCE Greek verse text by Aratus, in turn based on a prose treatise, the *Phoenomena*, written by Eudoxus of Cnidos a century earlier; Ptolemy's *Almagest* (probably ca. 142 CE); and later compositions, such as John Foxton's *Liber Cosmographiae* (1408).

Astronomy (the observation of the stars) was not originally distinguished from *astrology* (divination by means of the observation of the stars). The Mesopotamians and Egyptians were instrumental in the early development of astronomy and astrology. Their practices were transmitted to the Greek and Roman worlds and subsequently to Islam and the medieval West. The study of astronomy and astrology declined in the first Christian centuries, astrology because its system of prognostication ran counter to what was understood as the preordained plan of Christian salvation. In the CAROLINGIAN period, however, with its revival of CLASSICAL TEXTS, both subjects were taken up again.

In the twelfth century, Arabic learning, which had preserved aspects of classical knowledge in astronomy and astrology as well as other subjects, increasingly influenced the West. Western thinkers became interested in the works of the ancient Greeks and of Al-Bitruji (fl. ca. 1190), and by the thirteenth century a controversy developed—in which the theologian Albertus Magnus and the philosopher-scientist Roger Bacon played important parts—concerning the respective merits of the ancient and Arabic authors. The rise of new methods of astronomy during the fifteenth century and the 1543 publication of Nicolaus Copernicus's theory that the earth revolved around the sun did much to damage the academic credibility of astrology.

ATELIER See WORKSHOP.

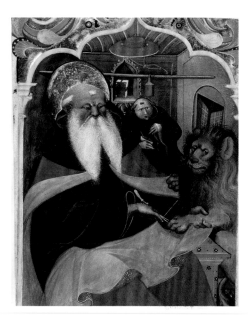

ATTRIBUTE
Master of the Murano Gradual, *Saint Jerome Extracting a Thorn from a Lion's Paw*. Cutting from a gradual, northern Italy, ca. second quarter of the fifteenth century.
21 × 16.5 cm (8¼ × 6½ in.).
Los Angeles, JPGM, Ms. 106 (2010.21), recto

The legend illustrated here that Saint Jerome removed a thorn from a lion's paw led to the medieval custom of picturing Jerome as an ecclesiastic accompanied by his attribute, a benign lion.

ATTRIBUTE

An object that identifies a person, most often a saint. Saint Catherine, for example, is usually depicted with a wheel, one of the instruments with which she was tortured for professing her Christian faith.

AUTHOR PORTRAIT

A MINIATURE or HISTORIATED INITIAL depicting the author of a text. Author portraits were known in ANTIQUITY and appear in manuscripts throughout the Middle Ages in a variety of texts.

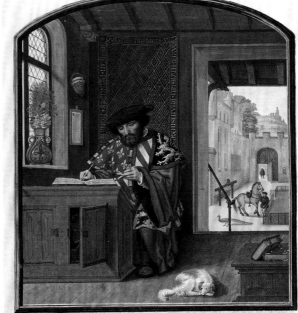

AUTHOR PORTRAIT
Simon Bening, *The King of Arms of the Golden Fleece Writing about Jacques de Lalaing*. In *Livre des faits de Jacques de Lalaing*, Flanders, ca. 1530. 36.4 × 26.2 cm (14⁵⁄₁₆ × 10⁵⁄₁₆ in.). Los Angeles, JPGM, Ms. 114 (2016.7), fol. 10

BANDS

A general term for sewing supports onto which are sewn the folded sections (GATHERINGS) of a book. The bands can appear as either flat or raised on the book's SPINE. See SEWING ON SUPPORTS.

BAS-DE-PAGE SCENES

Initial *H: Moses Striking Water from the Rock and Israelites Drawing Water*. In a Bible known as the Abbey Bible, Bologna, ca. 1250–62. 26.8 × 19.7 cm (10⁹⁄₁₆ × 7¾ in.). Los Angeles, JPGM, Ms. 107 (2011.23), fol. 62 (detail)

The theme of fishermen for the *bas-de-page* scene on this page was inspired by the subject of the initial above, in which the Israelites are shown drawing water from a miraculous stream.

BAS-DE-PAGE SCENES

Scenes or images, at the bottom of the page, that are usually unframed and may or may not refer to the text or another image on the page, borrowing the French meaning "bottom of the page." They are a characteristic feature of GOTHIC illumination.

BEATUS INITIAL See PSALTER.

BENEDICTIONAL

A Christian SERVICE BOOK consisting of blessings given by a bishop at MASS arranged according to the liturgical year. Some lavishly illuminated examples were produced in ANGLO-SAXON England for individual bishops such as Æthelwold of Winchester (d. 984).

BESTIARY

Descriptions and tales of animals and birds (both real and imaginary) that are imbued with Christian symbolism or moral lessons, and the books containing them. The rising of the phoenix from the pyre, for example, is interpreted as a reflection of Christ's Resurrection.

The bestiary, in all its varied manifestations, enjoyed great popularity during the twelfth and thirteenth centuries, especially in England. Among the most beloved of illuminated books, a favorite of monastic communities and the literate LAITY, it functioned as a library and SCHOOL BOOK and as source material for sermons. The text was frequently illustrated, and motifs drawn from it are widely encountered in other decorative contexts, including BAS-DE-PAGE SCENES, HERALDRY, and encyclopedic world maps (see MAPPA MUNDI).

The core of the text originated in a Greek work known as the *Physiologus* ("naturalist" or "allegorist"), which is thought to have been compiled in Alexandria around the second century CE by a Christian ascetic. In the *Physiologus*, discussions of the characteristics of about fifty creatures, plants, and stones, along with the etymologies of their names, were distilled from classical writings (including the works of authors such as Herodotus, Aristotle, and Pliny the Elder) and the Christian tradition.

The *Physiologus* was influential for a thousand years, being translated into Arabic, Armenian, Ethiopic, Syriac, and other VERNACULAR languages; the later medieval bestiaries descended primarily from Latin translations that began to appear as early as the fifth century. More beasts and additional materials were adjoined to the Latin *Physiologus* from the *Etymologies* of the seventh-century Spanish bishop Isidore of Seville and other selected sources. This expanded text gave rise to a number of French translations. Philippe de Thaon produced a rhyming version in Anglo-Norman (ca. 1125), dedicated to Aelis de Louvain, second wife of Henry I of England. Other medieval versions include that of Gervaise, written in French (perhaps in Normandy) in the thirteenth century; that of Guillaume le Clerc (the most popular version), written in the early thirteenth century in French by a Norman priest working in England; and two versions ascribed to Pierre de Beauvais, "le Picard," composed in the dialect of Picardy, also in the early thirteenth century. The Latin bestiary still flourished alongside its French counterparts and was often produced in luxurious illustrated copies in England and France during the twelfth and thirteenth centuries. Scholars have arranged surviving examples into groups on the basis of variations in their texts and programs of ILLUMINATION.

BESTIARY
A Crocodile. In a
bestiary known as the
Northumberland Bestiary,
England, ca. 1250–60.
21 × 15.7 cm (8¼ × 6³⁄₁₆ in.).
Los Angeles, JPGM,
Ms. 100 (2007.16), fol. 49v
(detail)

Bianchi girari See WHITE VINE-STEM.

BIBLE

The sacred writings of Christianity. A number of Latin versions of the Bible, translated from Greek and Hebrew, were used in the EARLY CHRISTIAN Church; these are known as Old Latin versions. To establish a measure of uniformity among these various translations, Saint Jerome, encouraged by Pope Damasus I, undertook a new translation of the whole Bible, working from the Greek and the Hebrew for the Old Testament. The translation he produced, begun about 382 and completed in 404, is known as the Vulgate. Throughout the Middle Ages it was common for portions of the Bible to be contained in separate volumes (such as the PENTATEUCH, HEXATEUCH, OCTATEUCH, and GOSPEL BOOKS). For liturgical purposes, scriptural texts (or readings from them) were incorporated into EPISTOLARIES and GOSPEL LECTIONARIES.

Beginning in the fourth century, when Christianity became the official religion of the Roman Empire (in 380), luxurious CODICES of the Bible and its parts were produced. During the early Middle Ages, corruptions of the Vulgate and intrusions from Old Latin versions led several scholars to attempt to standardize the biblical texts; Cassiodorus in the sixth century and, in the CAROLINGIAN period, Alcuin of York (d. 804) and Theodulf of Orléans (d. 821) are the best known of these. In part as a result of their endeavors, a group of large, luxuriously written and illuminated editions of the complete Bible were produced. Cassiodorus's nine-volume edition influenced Bible manuscripts in ANGLO-SAXON England, and the SCRIPTORIA at Tours produced dozens of Bibles over the course of the first six decades of the ninth century. In the ROMANESQUE period, many of the Bibles produced were large in format. In the late twelfth and thirteenth centuries, a practice arose, stimulated by the universities, of producing small-format Bibles (or parts thereof) with condensed SCRIPT and HISTORIATED INITIALS.

Scriptural texts were translated into the VERNACULAR as early as the eighth century (in Anglo-Saxon England), but many of the major developments in vernacular translation took place from the fourteenth to the sixteenth century, beginning with followers of John Wycliffe (d. 1384), who over time made the first complete translation of the Bible into Middle English; the German translation made by Martin Luther in the 1520s is still in use today.

BIBLE HISTORIALE

The biblical narrative in prose form, written by Guyart des Moulins (1291–94) and based on his translation into French of the *Historia scholastica* of Peter Comestor, interspersed with a French translation of the BIBLE produced in Paris around 1250. The illustrations accompanying the *Bible historiale* (usually in the form of COLUMN PICTURES) depict many scenes not normally found in the standard repertory of biblical images and also include representations of the compilation and translation of the text.

BIBLE HISTORIALE
Master of Jean de
Mandeville, *Jeremiah
before Jerusalem in Flames.*
In a *Bible historiale*, Paris,
ca. 1360–70. 34.9 × 26 cm
(13¾ × 10¼ in.). Los
Angeles, JPGM,
Ms. 1, vol. 2
(84.MA.40.2), fol. 86v

BIBLE MORALISÉE

A type of medieval picture BIBLE, also known as the *Bible historiée*, *Bible allégorisée*, and *Emblèmes bibliques.* Developed in the early thirteenth century, the book features paired medallion images arranged in columns accompanied by short biblical passages and related COMMENTARIES with moral or allegorical lessons (in Latin or in French). The most sumptuous extant *Bible moralisée* contains about five thousand images. Other sorts of picture Bibles also existed (see BIBLIA PAUPERUM).

BIBLIA PAUPERUM

A book that consists of a series of captioned MINIATURES illustrating parallels between the Old and New Testaments (see TYPOLOGY), from the Latin meaning "Bible of the poor." Scenes from the life of Christ were accompanied by Old Testament scenes and figures of the prophets. Although few manuscript examples have survived, these picture books circulated in print and are known to have been very popular in the late Middle Ages, especially for religious instruction among poorer clergy and those members of lay society who were not especially learned.

BIFOLIUM (PL. BIFOLIA)

A sheet of writing support material (generally PARCHMENT during the Middle Ages) folded in half to produce two leaves (i.e., four pages). A number of bifolia folded together form a GATHERING.

BINDER

A person wholly or partly responsible for sewing a CODEX and supplying it with covers (i.e., the bookbinder who supplies the binding). Evidence suggests that the binding of books was done within monastic SCRIPTORIA in the early Middle Ages. Following the rise of universities in the late twelfth century, BINDING became the preserve of the STATIONER. The term *binder* can also be used to describe a BINDING MEDIUM.

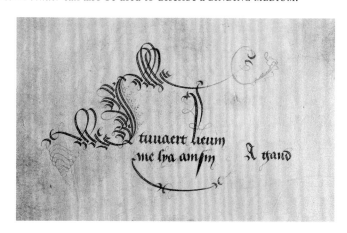

BINDER

Inside front cover. Book of hours known as the Llangattock Hours, Belgium, ca. 1450–59. 26.4 × 18.4 cm (10⅜ × 7¼ in.). Los Angeles, JPGM, Ms. Ludwig IX 7 (83.ML.103) (detail)

This elegant binder's inscription speaking in the voice of the manuscript reports, in Dutch, "Lieven Stuvaert bound me together at Ghent."

BINDING

The operations of sewing and covering a book, done by a BINDER; the term also refers to the resulting product of such an operation. After the FOLIOS of a CODEX have been written and illuminated, they are assembled into GATHERINGS and sewn together. Generally they are sewn onto supports (CORDS or THONGS), although there also exists an unsupported form of sewing in which only the thread fastens the gatherings together and attaches the boards (see COPTIC SEWING). The loose ends of the sewing supports (called *slips*) are then laced onto BOARDS, which were normally made of wood in medieval bindings (see BOARDS, CHANNELING, and PEGGING) and covered. If covered with TANNED leather or ALUM-TAWED SKIN, the binding could be decorated in a wide variety of ways (see CUT LEATHER, PANEL STAMPED, and TOOLING). Closure mechanisms would hold the book shut (see CLASP AND CATCH and STRAP AND PIN), and BOSSES might be added to protect the binding from wear. The operation of binding was generally undertaken in the SCRIPTORIUM or by STATIONERS. See also END-BANDS, KETTLE STITCH, LIMP BINDING, PASTEDOWN, SEWING ON SUPPORTS, SEWING STATIONS, and TREASURE BINDING.

Binding medium

The liquid that binds together particles of PIGMENT to make paint. A binding medium provides cohesion of the pigment particles and helps paint adhere to the surface on which it is painted. Clarified egg white (GLAIR) and gum (such as gum Arabic, sap from the acacia tree) were the principal binding media used in manuscript ILLUMINATION. Glues (such as fish glue or PARCHMENT size) were also used as a binding medium as well as for GILDING.

Blind tooling

Impressed designs or lettering made on the covering material of a BINDING. Blind tooling is made with a heated metal hand tool that is pressed into dampened covering leather or ALUM-TAWED SKIN on the BOARDS and SPINE of a binding without the addition of color or gold in the impressed designs (see the illustration accompanying STRAP AND PIN). See TOOLING.

Blocking

A condition affecting the pages of a manuscript in which the surfaces of the PARCHMENT or PAPER have fused together due to exposure to moisture, an excess application of adhesive, or the presence of other deleterious material that might cause multiple pages to adhere together, creating a solid mass.

Boards

The stiff covers at the front and back of a CODEX that protects its leaves. Wood—often oak, beech, or another hardwood—was the material generally used for the boards of medieval manuscripts until the early sixteenth century. The boards could be fairly thick, cut with either a square or beveled profile HEAD, TAIL, and FORE EDGES (the latter typically a German and central European feature of the late Middle Ages). The use of pasteboard for book boards became popular in the sixteenth century; these were formed from pasted sheets of paper including discarded manuscript leaves and printers' waste. In later centuries, boards were made from rope fiber and strawboard. The boards were attached to the sewn GATHERINGS by lacing the THONGS or CORDS into the boards and securing them (see CHANNELING and PEGGING). The boards and SPINE were then usually covered with damp leather or ALUM-TAWED SKIN (although PARCHMENT or textile might be used), which was folded over the edges and glued down to the inside faces of the boards, forming what are called TURN-INS. When no stiff boards are present, the covering of a book is called a LIMP BINDING.

Bookmarker

A device used for marking a place in a book. Tabs or knotted strips of leather, PARCHMENT, or ALUM-TAWED SKIN (sometimes colored) were attached to (or cut and folded into) the FORE EDGE of a page to mark the beginning of a significant text. Alternately, strips of textile ribbon or other material could be knotted together or attached to the headband (see ENDBANDS) to create a multistrand bookmarker. Bookmarkers of this

BOOKMARKER
Missal, Mainz, ca. 1500–
1505. 38.7 × 27.9 cm (15¼ ×
11 in.). Los Angeles, JPGM,
Ms. 18 (86.MG.480)

Colored bookmarkers
of graduated sizes mark
the fore edge of this
missal, with the largest
knotted tabs for the most
important texts for the
celebration of mass.

latter type might even carry a device used in conjunction with the text to be marked, such as a VOLVELLE, to assist in relevant chronological or astronomical calculations. Fore-edge straps, flowers, and other flat items might also be used as bookmarkers.

BOOK OF HOURS

A book used in private devotions, also called a *primer* or *horae.* Its central text, the Little Office of the Blessed Virgin (or Hours of the Virgin), is modeled on the DIVINE OFFICE and represents a shorter version of the devotions performed at the eight

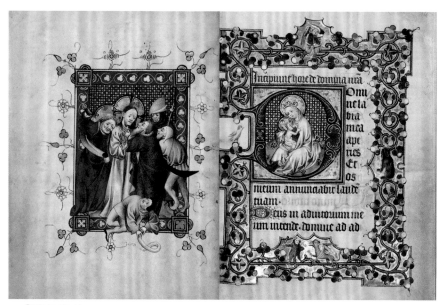

BOOK OF HOURS
Masters of Dirc van Delf, *The Betrayal of Christ* and initial *D: The Virgin and Child.* In a book of hours,
the Netherlands, probably Utrecht, ca. 1405–10. 16.5 × 11.7 cm (6½ × 4⅝ in.). Los Angeles, JPGM,
Ms. 40 (90.ML.139), fols. 13v–14

canonical hours by the professional religious. The text, known from the tenth century, was originally recited only by ecclesiastics; it entered into more popular use by the end of the twelfth century, often being included in PSALTERS, the book more commonly used for private devotions before the emergence of the book of hours. The private recitation of the Little Office of the Blessed Virgin is an expression of the LAITY's desire to imitate the prayer life of the religious.

In books of hours, the Little Office of the Blessed Virgin was often supplemented by other texts: a liturgical CALENDAR, a LITANY OF SAINTS, SUFFRAGES, the Office of the Dead (which had emerged by the ninth century), the Penitential Psalms (Psalms 6, 31, 37, 50, 101, 129, and 142), the Gradual Psalms (Psalms 119–33), and prayers. Additional offices, such as the Short Office of the Cross, the Hours of the Holy Spirit, the Hours of the Trinity, and the Hours of the Passion, could also form part of a book of hours. The book of hours took its standard form in the thirteenth century and continued in general use until the sixteenth century. The texts of books of hours vary in accordance with USE.

Books of hours were medieval best-sellers and have survived in relatively high quantity. They are nearly always illuminated and often include a MINIATURE or set of miniatures at the beginning of each major textual division. These subjects include scenes from the lives of the Virgin, Christ, and King David; depictions of the saints; and themes relating to death and judgment. The PATRON was also sometimes portrayed.

BOOKPLATE See EX LIBRIS INSCRIPTION.

BORDER

The painted area that surrounds the text and/or image and may occupy margins and intercolumnar space. Painted borders were popular in late medieval and RENAISSANCE manuscripts, having evolved from the extenders that sprang from the painted INITIALS of GOTHIC books. A full border surrounds an image or text on all sides, while a partial border frames only part of the area. Like an initial, a border can be INHABITED or HISTO-RIATED, and many feature ACANTHUS. A popular form of border in the fourteenth and fifteenth centuries was the spray border, consisting of RINCEAUX of fine foliate tendrils with small gilded leaves. During the fifteenth century, a form of border became popular (initially within the works of the Ghent-Bruges School and subsequently in French and Italian illumination) in which naturalistically rendered flora and fauna were placed, as if strewn, on a ground (often GILDED). These are termed *scatter*, *strewn*, or TROMPE L'OEIL borders. HUMANIST manuscripts often feature WHITE VINE-STEM borders.

BOSS

A protruding ornament, usually of metal applied to the outer surfaces of the BOARDS. Bosses served both decorative and protective functions, preventing wear to the BINDING's covering material. Bosses are typically found on wooden board bindings that were meant to lie flat on a lectern. See also CENTERPIECE and CORNERPIECE.

Bounding lines

The vertical lines supplied during RULING to guide the justification of the text and its ancillaries (such as INITIALS).

Breviary

A Christian SERVICE BOOK containing the texts necessary for the celebration of the DIVINE OFFICE. A breviary is often adorned with DECORATED or HISTORIATED INITIALS, and more luxurious copies may contain MINIATURES depicting biblical scenes or the performance of the office.

Beginning in the eleventh century, the various volumes used in the Divine Office (PSALTER, ANTIPHONAL, COLLECTAR, MARTYROLOGY, and others) were combined to form the breviary, which was initially used only by monks. The breviary's contents are divided into TEMPORALE, SANCTORALE, and COMMON OF SAINTS and vary in detail in accordance with the rite of the religious order and USE.

BREVIARY
Initial *V: The Descent of the Holy Spirit*. In a breviary, Montecassino, 1153. 19.2 × 13.2 cm (7 9/16 × 5 3/16 in.). Los Angeles, JPGM, Ms. Ludwig IX 1 (83.ML.97), fol. 289

Brush

Animal hair set within wooden handles or quill shafts and used to paint medieval ILLUMINATIONS, replacing the frayed reed brushes of ANTIQUITY. Brushes used by ILLUMINATORS were typically made of ermine or squirrel hair.

Burgundian

A courtly style of art that flourished under the patronage of the Dukes of Burgundy, primarily in Flanders, from the late fourteenth to the mid-sixteenth century.

Burgundy had been established as a GERMANIC kingdom in the fifth century, its art being Germanic in character until the kingdom was conquered by the Franks and eventually absorbed into the CAROLINGIAN Empire. It is to a later phase in the history of the region, however, that the term is generally applied in discussing manuscripts.

In 1384 the Duchy of Burgundy and the county of Franche-Comté were united as a consequence of the marriage (in 1369) of Philip the Bold, Duke of Burgundy, and Margaret of Flanders (heiress to Franche-Comté). The union initiated a century of Burgundian greatness. Strategically placed as it was between France and Germany, Burgundy became a major Northern European political and economic power. The arts flourished under the patronage of Dukes Philip the Good (r. 1419–67) and Charles the Bold (r. 1467–77). This period of creativity in the arts continued after the duchy's absorption into the Holy Roman Empire in 1477; indeed, it lasted well into the sixteenth century in the work of artists such as Simon Bening.

Books played a key role in Burgundian culture, with many illuminated CHRONICLES, ROMANCES, and devotional works being commissioned in Flanders, the center of Burgundian power. Burgundian patronage brought Flemish ILLUMINATION and SCRIPT (*lettre bourguignonne* or *bâtarde*) to international prominence with a luxurious, highly polished style. Burgundian illumination was influenced by the observation of court life and by contemporary Flemish panel painting, particularly the latter's rendering of space and use of opulent colors. David Aubert was an important SCRIBE within this milieu, and prominent ILLUMINATORS included Simon Marmion and Gerard Horenbout.

Burnishing

A technique for enhancing the smoothness and reflective sheen of a material, such as metal leaf or a metallic PIGMENT, by polishing with a burnisher (a smooth, hard stone, metal, or bone set into a handle). See also GILDING.

Byzantine

Of or pertaining to the empire named for the ancient city of Byzantium, reinaugurated as the eastern capital of the Roman Empire by Emperor Constantine the Great in 324. In 330 the city was renamed after him as Constantinople. The eastern Roman Empire withstood the barbarian onslaught of the fifth century, but from the seventh century on suffered frequent invasions by Islamic forces.

The culture of Byzantium influenced the entire Greek world, including parts of Asia Minor, as well as the regions of Italy with which it was politically or commercially engaged: Ravenna, the Veneto, southern Italy, and Sicily, where medieval art exhibited substantial Byzantine influence. Byzantine culture also spread northward when the Slavs, Russians, and other central European groups converted to Christianity. The period of the Iconoclastic Controversy (726–843), during which many political and

BYZANTINE
Saint Mark. Detached
leaf from a Gospel book
or New Testament,
Constantinople, ca. 1300.
19.2 × 14.5 cm (7⁹⁄₁₆ ×
5¹¹⁄₁₆ in.). Los Angeles,
JPGM, Ms. 70 (2002.23),
verso

ecclesiastical leaders of the Byzantine Empire opposed the use of religious images, curbed the spread of Byzantine visual culture to the West.

There were, nevertheless, important phases of Byzantine influence on the West, notably during the OTTONIAN and parts of the ROMANESQUE periods. The Crusades of the eleventh to the thirteenth century, when western European forces sought to wrest Jerusalem from Muslim rule, again made Byzantine culture more accessible to the West, especially during the years of the Western control of Byzantium (1204–61) following the Fourth Crusade. The TRANSITIONAL STYLE in Western art, from the late twelfth to the early thirteenth century, is in part a product of this cultural interchange.

The Byzantine Empire itself enjoyed something of a golden age from 850 to 1050, especially under the Macedonian emperors, accompanied by a flowering of the arts. In the fourteenth century, the Palaeologan dynasty (1261–1453) supported culture and monasticism. In 1453, however, Constantinople fell to the Ottoman Turks, and the Byzantine Empire came to an end.

Byzantine manuscript ILLUMINATION is characterized by a relatively fixed ICONOGRAPHY of biblical scenes, the use of gold backgrounds, and a generally NATURALISTIC rendering of figures.

Cadelle
Nicolas Spierinc,
decorated text page. In the
Prayer Book of Charles
the Bold, Belgium, 1469.
12.4 × 9.2 cm (4⅞ ×
3⅝ in.). Los Angeles,
JPGM, Ms. 37 (89.ML.35),
fol. 16

Cadelle

A decorative embellishment to CALLIGRAPHY, often with parallel branching broad-edged pen strokes on the ascenders and descenders of a letterform. These flourished extensions that might occupy the upper and lower margins are decorated further with vegetal forms or transformed into animal, human, and hybrid figures.

Calendar

Most medieval calendars are found in liturgical and devotional manuscripts. In this context, they identify feast days pertinent to the PATRON and the region, using different colors to highlight important feasts, such as Christmas or the Annunciation (so-called *red-letter days*). The saints' feasts and OBITS in calendars often supply valuable evidence of the ORIGIN and PROVENANCE of a manuscript. Calendars in liturgical and devotional books are often illuminated, the two most popular schemes being the labors of the months (see OCCUPATIONAL CALENDAR) and the signs of the zodiac, both ultimately of classical origin but increasingly popular from the ninth century on. Calendars are often accompanied in religious books by computus texts, such as Easter tables, for calculating movable feasts. Private, university, medical, astronomical, and official administrative texts also might include calendars.

Calendar

A Man Treading Grapes; Zodiacal Sign of Libra. In a book of hours known as the Katherine Hours, Tours, ca. 1480–85. 16.4 × 11.6 cm (6⁷⁄₁₆ × 4⁹⁄₁₆ in.). Los Angeles, JPGM, Ms. 6 (84.ML.746), fol. 5

On this calendar page, the most important feasts are written in blue. In the border, the scene of a man treading grapes in a vat represents the labor for the month of September, and the zodiacal sign of Libra is represented by a woman holding a balance.

The Middle Ages inherited the Julian (Old Style) calendar introduced by Julius Caesar in 45 BCE. This contained a 365-day year, with an extra day every fourth year to reconcile the calendar with the solar year, calculated as 365 days and 6 hours. The year was divided into twelve months. Each month had named days: Kalends, Nones, and Ides, the unnamed days in between being reckoned backward from the next Kalends, Nones, or Ides. Each month had *dies Aegyptiacae* ("Egyptian," or unlucky, days). Medieval Christians also understood an ecclesiastical division of the year into weeks, each with seven named days, and with dating by reference to church feasts or occasions such as fairs and rent days.

In the medieval West, Christians generally calculated the years from the purported year of Jesus's birth, except where the Hispanic era (reckoned from 38 BCE) prevailed (much of the Iberian Peninsula and parts of southern France).

Other calendrical calculations were used in the Middle Ages as alternatives to or in association with the Christian era. Among these was the indiction, originally a civil reckoning that computed from 312 CE in fifteen-year cycles and was used for privileges and legal documents until relegated to notarial use in the late thirteenth century. Pontifical and regnal years also served calendrical purposes, relating a date to the person under whose jurisdiction the calendar was issued (for example, the second year of the reign of Henry III). Certain administrative offices had their own systems (the English Exchequer's financial year ran from Michaelmas [September 29] to Michaelmas).

The inclusion of golden numbers, epacts, dominical letters, and concurrents for the calculation of movable feasts (often added as tables) rendered a calendar perpetual or continually functional. The calculations were concerned primarily with establishing the relationship between the solar year and the phases of the moon so that the date of Easter could be determined.

CALLIGRAPHY

Writing that exhibits exceptional and often self-conscious artistry and aesthetic quality in design and execution, from the Greek for "beautiful writing." The art of fine writing was appreciated in the Middle Ages and the RENAISSANCE, with certain SCRIBES becoming famous for their beautiful and decorative script. A number of treatises on calligraphy and specimen books of script (such as copy books and alphabet books) were produced. Following the introduction of printing, fine writing was still taught by writing MASTERS, calligraphers, and ILLUMINATORS, who continued to produce handwritten pieces as works of art and for formal, commemorative, and display purposes. See the illustration accompanying CADELLE.

CAMPAIGN

A phase of work in the production of a manuscript. A manuscript could be made over a period of time in several campaigns of work; additional material might be added in a separate, later campaign.

CAMPAIGN
Decorated text page.
In *Historia de duobus amantibus*, France, ca. 1460–70. 17.6 × 11.4 cm (6¹⁵⁄₁₆ × 4½ in.). Los Angeles, JPGM, Ms. 68 (2001.45), fol. 32v

On this page, the painting was done in at least two campaigns, and the miniature remains to be painted. The decorated initial and the border were presumably executed by artists specializing in those secondary components of the illumination.

CANONICAL HOURS See DIVINE OFFICE.

CANON PAGE

The opening page of the canon of the MASS, the portion of the service in which the bread and wine of the Eucharist are consecrated. Canon pages were often illuminated in medieval MISSALS and SACRAMENTARIES, with the subject matter often inspired by the cruciform shape of the letter *T* in the prayer *Te igitur.*

CANON TABLES
T'oros Roslin, canon table page. In a Gospel book known as the Zeyt'un Gospels, Hromklay, 1256. 26.5 × 19 cm (10⁷⁄₁₆ × 7½ in.). Los Angeles, JPGM, Ms. 59 (94.MB.71), fol. 5v

CANON TABLES

Tables of numbers reflecting a system of consecutive numbering of the text of each Gospel, arranged in columns, indicating the concordance of passages among the Gospels. Canon tables were generally placed at the beginning of the Gospels in GOSPEL BOOKS, BIBLES, and New Testaments (the Gospels plus Acts, Epistles, and the APOCA-LYPSE), especially during the early Middle Ages. Canon tables were often set within arched surrounds of an architectural character. Sometimes EVANGELIST SYMBOLS were included to identify the Gospels referred to in the columns of numbers; these are known as *beast canon tables.*

Carolingian

Of or pertaining to the dynastic rulers of Francia from 751, when Pepin the Short was named king of the Franks. The Carolingian Empire (which embraced much of northern Europe and Italy) was established under Charlemagne (742–814), who became emperor in 800. In 843 the empire was divided into three parts by the Treaty of Verdun. The fragmentation of Charlemagne's realm continued, destroying any semblance of unity. Although Carolingians ruled some areas until the late tenth century, the OTTONIAN dynasty assumed imperial power in 962.

Charlemagne and his immediate successors sought to establish cultural cohesion and political stability throughout the disparate territories of the empire. These efforts led to a flowering of culture and to ecclesiastical reform. The latter included the standardization of texts, for which reason Charlemagne's adviser, Alcuin of York (d. 804), undertook a revision of the BIBLE. During the ninth century, the SCRIPTORIA at Tours produced large, illuminated Bibles for circulation. The SCRIPT known as *Caroline minuscule* was also an important contribution of the period to medieval manuscript culture. Standardized and easily legible, it was promoted throughout the Empire.

Charlemagne's claims to the imperial status of Roman emperors and his extension of Carolingian power into Italy fostered a revival of CLASSICAL TEXTS and of the style

Carolingian

Decorated initial *P*. Detached leaf from a Bible, Tours, ca. 845. 46.4 × 33.7 cm (18¼ × 13¼ in.). Los Angeles, JPGM, Ms. Ludwig I 1 (83.MA.50), leaf 10

This page displays the characteristic features of the opening of a new section of text in a Carolingian Bible. The new text is announced in colored capital letters; a painted initial marks the beginning of the text proper; and the initial is followed by eight lines in display script before the text continues in Caroline minuscule.

and imagery of ancient art. In addition to preserving many works from ANTIQUITY, the Carolingian period witnessed the composition of many new texts by scholars, including Alcuin, Einhard, Paul the Deacon, Hrabanus Maurus, Walafrid Strabo, and John Scotus Eriugena.

The earliest monument of Carolingian ILLUMINATION, the Godescalc evangelistary, dates to ca. 781–83; at this time, the scriptorium at Corbie was experimenting with early Caroline minuscule. The production of manuscripts flourished until the late ninth century, with a number of distinctive local styles of illumination emerging. The Court School of Charlemagne, for example, favored heavily painted works with a NATURAL-ISTIC rendering of figures and opulent use of gold, silver, and purple (redolent of imperial Roman and BYZANTINE influence). The artists of the School of Reims worked in an agitated, IMPRESSIONISTIC STYLE of classical inspiration, while illuminators of the Metz School employed a decorative style featuring ACANTHUS ornament. In the ninth century, the Franco-Saxon style also emerged, showing INSULAR influence in its zoo-morphic and INTERLACE decoration. Carolingian book production was also influenced by PRE-CAROLINGIAN European developments.

CARPET PAGE

An ornamental page particularly favored in INSULAR art that derives its name from its visual similarity to an Eastern carpet. Carpet pages often incorporate a cross into their design. Unlike decorated INCIPIT PAGES, carpet pages do not carry text. They generally separated the four Gospels in GOSPEL BOOKS, and their use in Christian art may be of COPTIC origin.

CARTOLAIO (PL. CARTOLAI) See STATIONER.

CARTOUCHE An ornament featuring carved scrolls.

CARTULARY A collection of CHARTERS in book form.

CATCHWORD

A word written at the end (generally in the lower margin) of a GATHERING that signals the first word on the following page. Catchwords facilitate the correct arrangement of the gatherings during BINDING.

CELTIC

The Celts were originally an Iron Age people occupying central and western Europe, whose culture spread throughout much of the West. Following Roman expansionism of the first century BCE to the first century CE, the Celts were pushed back to areas of the Atlantic seaboard (Ireland, Scotland, Man, Wales, Cornwall, and Brittany). Celtic art is characterized by a sophisticated abstract approach, featuring devices such as the *pelta* (a semicircular shield), the *trumpet spiral* (a spiral terminating in a trumpet shape), and the *triquetra* (a three-cornered shape). It often incorporates anthropomorphic and

zoomorphic features, sometimes of an ambiguous character. *Ultimate La Tène* art, named after a Celtic Iron Age style, flourishes even to the present.

Beginning in the fifth century CE, Ireland, along with some other areas of Celtic Britain, developed a thriving literate Christian tradition and played a key role in preserving the learning of ANTIQUITY and the early Church. This was transmitted to ANGLO-SAXON England from the sixth century on, giving rise to INSULAR culture.

CENTERPIECE

A decorative element on the cover of a BINDING, positioned at the center of a BOARD. A centerpiece could be either blind or gold tooled (see BLIND TOOLING and TOOLING). If fashioned out of metal, a centerpiece might also contain a BOSS and be combined with metal CORNERPIECES.

CHAINED BOOK

A book whose BINDING has a chain for attachment to a bookshelf, desk, or lectern so that it could not be removed from a library. The presence of a chain or the fitting for one generally indicates that the book was owned by a college or ecclesiastical establishment.

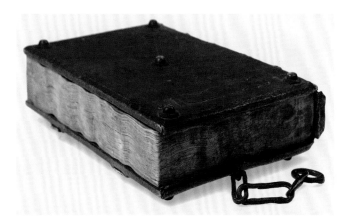

CHAINED BOOK
Nicholas of Lyra,
Postilla litteralis in vetus testamentum, Germany,
ca. 1450–70, in a later binding. Leaf: 30.8 ×
21 cm (12³⁄₁₆ × 8⁵⁄₁₆ in.).
Kalamazoo, Western
Michigan University
Libraries, Ms. 177

CHALK

A natural form of calcium carbonate, chalk was used for a variety of purposes in manuscript production: as a white POUNCE in the preparation of the surfaces of PARCHMENT, as a colored drawing medium, or as a base for certain organic colorants used as INKS and in ILLUMINATION (see PIGMENT).

CHANNELING

A system of grooves cut into binding BOARDS into which the sewing threads from the sewn GATHERINGS (as in COPTIC SEWING) or sewing supports (such as THONGS or CORDS) could be recessed. By accommodating the method of board attachment, the laced sewing supports or threads would be flush on the flat surfaces of the boards. See also PEGGING.

Channel style

A style of ILLUMINATION found in manuscripts produced in the generations around the year 1200 on both sides of the English Channel. The style famously features painted INITIALS that include naked blue men seeming to hold up portions of the letters. See the illustration accompanying DECRETALS.

Charter

A document recording an act considered to come from an acknowledged authority, most commonly the grant of property or of rights relating to property.

Chemise binding

A secondary covering of a book. The medieval precursor to the modern dust jacket, a chemise could be made of leather, ALUM-TAWED SKIN, or textile. Held secure to the BOARDS by envelope pockets, the chemise extended beyond the board edges to wrap around the FORE EDGE of the book and at the HEAD and TAIL. Chemise bindings varied in form from protective wrappers for monastic LIBRARY BOOKS in the twelfth century to luxurious embellishments for BOOKS OF HOURS and PRAYER BOOKS in the fifteenth and sixteenth centuries.

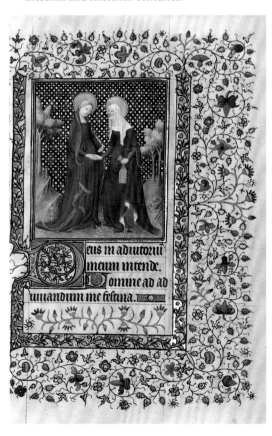

CHEMISE BINDING
Boucicaut Master and workshop, *The Visitation.* In a book of hours, Paris, ca. 1415–20. 20.5 × 14.8 cm (8¹⁄₁₆ × 5¹³⁄₁₆ in.). Los Angeles, JPGM, Ms. 22 (86.ML.571), fol. 48 and detail

In this miniature, Saint Elizabeth is shown holding a book bound in a green chemise binding, its wide skirt allowing it to be grasped easily in the hand.

CHI-RHO

A monogram composed of the Greek letters *chi* and *rho* (taking the form of the letters *X* and *P*), the first two characters of the name of Christ in Greek. It was often used in EARLY CHRISTIAN art. Decorated Chi-Rho pages are found in early medieval GOSPEL BOOKS, at Matthew 1:18. See the illustration accompanying MARGINALIA.

CHOIR BOOK

A SERVICE BOOK containing the parts of the MASS or the DIVINE OFFICE (or, very rarely, both) sung by the choir. See also ANTIPHONAL and GRADUAL.

CHRONICLE

A chronological record of yearly events. Early chronicles took the form of world or universal histories, such as those written in the fourth century by Eusebius of Caesarea and in the fifth by Sulpicius Severus. Local chronicles began to appear in the ninth century; among the most notable are the *Frankish Royal Annals* and the *Anglo-Saxon*

CHRONICLE
Master of the Soane Josephus, *John of Gaunt Sailing for Brest and the Battle between the English and the Bretons.* In Jean Froissart, *Chroniques,* Book 3, Bruges, ca. 1480–83. 48 × 35 cm (18⅞ × 13¾ in.). Los Angeles, JPGM, Ms. Ludwig XIII 7 (83.MP.150), fol. 116v

Chronicle, and, in the early eleventh century, a history of the Saxon kings by the German bishop Thietmar of Merseburg. World chronicles continued to be written, perpetuated by historians such as Marianus Scotus in the late eleventh century. The *Historia ecclesiastica*, completed in 731 at Jarrow in northeastern England by the Venerable Bede, marked an influential new approach to the writing of history: Bede perceived a relationship of cause and effect between events, collated material in accordance with a central theme (the growth of Christianity in England), and promoted a consistent system of dating (from the Incarnation).

The Normans produced a number of chronicles relating to Normandy, England, and the Holy Land in the late eleventh and twelfth centuries; these include the *Gesta Normannorum ducum* of William of Jumièges, the *Gesta Guillelmi ducis Normannorum et regis Anglorum* of William of Poitiers, and the works of Sigebert of Gembloux, Robert of Torigni, and Ordericus Vitalis. History writing in Britain continued to proliferate throughout the twelfth and thirteenth centuries, with chronicles by Florence of Worcester, William of Malmesbury, Geoffrey of Monmouth, Gerald of Wales, and Matthew Paris. Important Continental historians of the thirteenth century include Salimbene di Adam (*Cronica*) and Vincent of Beauvais (*Speculum historiale*), the latter's approach representing a move toward a more encyclopedic world view. Histories based on the BIBLE, such as the thirteenth-century *Weltchronik* of Rudolf von Ems, were also compiled. The thirteenth century also witnessed a proliferation of VERNACULAR histories, among them Geoffrey of Villehardouin's *Conquête de Constantinople*, the *Histoire de Guillaume le Maréchal*, and the *Grandes Chroniques de France*. Jean Froissart's *Chroniques de France* of the fourteenth century fuses the traditional chronicle with the ROMANCE genre.

In the GOTHIC period, many chronicles were illustrated, a practice largely initiated by Gerald of Wales and Matthew Paris, who incorporated marginal drawings into some of their works. In the thirteenth century, some authors integrated pagan and Christian history by grafting books such as Peter of Poitiers's *Genealogy of Christ* onto universal chronicles. The genealogies of kings were also included, giving rise to a tradition of illuminated genealogical manuscripts, often in ROLL form. See the illustration accompanying ROLL.

CHRYSOGRAPHY

Writing in gold, from the Greek *chrysographia*, meaning "writing in gold." Chrysography can be made with either powdered gold mixed with a BINDING MEDIUM and applied with a QUILL PEN or BRUSH, or it can be gold leaf applied to a GROUND. The surface might be burnished to create a highly reflective shine or left unburnished (see BURNISHING). Gold chrysography (and silver *argyrography*) on PARCHMENT was used for EARLY CHRISTIAN, BYZANTINE, and Islamic texts and was practiced across the centuries, especially for sacred and luxury manuscripts. The term *chrysography* is also used to describe gold highlights and other details in painting, a technique that enjoyed particular popularity in panel painting and manuscript ILLUMINATION during the fifteenth century. See also PURPLE PAGES.

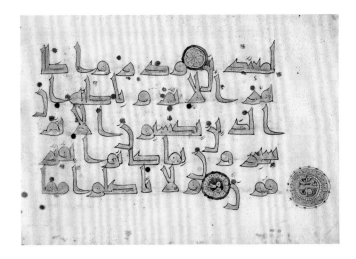

CHRYSOGRAPHY
Decorated text page. In a
Qur'an, probably Tunisia,
ninth century. 14.4 ×
20.8 cm (5¹¹⁄₁₆ × 8³⁄₁₆ in.).
Los Angeles, JPGM, Ms.
Ludwig X 1 (83.MM.118),
fol. 8v

As is befitting the dignity
and splendor of divine
revelation, the writing of
the Qur'an from which
this leaf comes is entirely
in gold leaf.

CLAREA See GLAIR.

CLASP AND CATCH

A two-part set of metal fittings attached to the BOARDS at the FORE EDGE of a BINDING and, more rarely, also at the HEAD and TAIL, used to fasten a book when closed and to prevent planar distortions in the PARCHMENT. Often used in pairs, each clasping mechanism consists of two parts, a curved metal fastener (sometimes attached to a leather strap) and a metal catch-plate, shaped to receive the end of the fastener. Clasps became popular during the fourteenth century, and the positioning of the clasp and catch may indicate the region of the binding's origin. For instance, on English and some French bindings the clasps fasten at the lower board, whereas elsewhere on the Continent the catch-plate is commonly on the upper board. For an alternative method of closure, see STRAP AND PIN.

CLASSICAL TEXTS

Literary works of Greek and Roman ANTIQUITY. Despite their pagan ancestry, classical texts were preserved during the early Middle Ages, including works by Dioscorides, Pliny the Elder, Cicero, Sextus Placitus, and Vitruvius, in fields ranging from medicine to rhetoric. Parts of Italy, Spain, and Gaul as well as the INSULAR and ANGLO-SAXON worlds did much to preserve classical learning. The Arabic-speaking world also became the custodian of a significant body of classical texts, notably the works of Plato, Aristotle, Galen of Pergamon, and Hippocrates, which were translated into Latin beginning in the twelfth century. The RENAISSANCE again witnessed a revival and systematic rediscovery of the classical past in the work of the HUMANISTS. Several PICTURE CYCLES were also inherited from classical texts.

CLASSICIZING STYLE

A style that emulates the form or character of the art of classical ANTIQUITY.

Clothlet

A piece of cloth impregnated with an organic dye. The dyed clothlet was soaked in a liquid BINDING MEDIUM to release the colorant, producing a transparent paint. Called *petiae* in Latin and *pezze* or *pezzette* in Italian, clothlets were a convenient way to store and preserve vegetal PIGMENTS. Clothlet colors are first mentioned in technical treatises in the late fourteenth century, coinciding with the growth of the European and Mediterranean textile trade. Glazes made from clothlet colors were often used to enhance other colors in manuscript ILLUMINATION, since they created a rich, glowing, and translucent effect. See MODELING.

Codex (pl. codices)

A book composed of folded sheets sewn along one edge, distinct from other writing vehicles such as the ROLL or TABLET. The codex, probably named from the Latin *caudex*, meaning "tree bark," originated in the first century CE. The earliest codices were composed of PAPYRUS, but PARCHMENT soon came to be the usual writing support material. The codex was particularly favored for Christian texts, and, by the fourth century, the codex had supplanted the roll as the favored vehicle for literary texts.

Codicology

The study of the physical structure of the book to better understand its production and history. The term was initially coined to mean a listing of texts but was subsequently applied to the study of book structures. From the late nineteenth century on, advances in the study of book structures led to the formulation of certain guidelines for reconstructing their historical development. Variable features include the number of leaves used in a GATHERING, the relative disposition of the HAIR and FLESH SIDES of the PARCHMENT, the manner of PRICKING and RULING (and whether these processes were conducted before or after the leaves were folded, one or more leaves at a time, and with or without the aid of a template), and how a book was sewn and bound. The examination of a book's structure can shed considerable light on its method of construction, place of ORIGIN, and date.

Collation

A description of a book's current and/or original structure, that is, the arrangement of its leaves and GATHERINGS. This information may be conveyed in diagrammatic form (showing the gatherings and their composition) or in a prose shorthand. In the latter, for example, "1^8 (wants 1, blank)" indicates that the first gathering was formed of eight leaves, the first of which is missing and was originally blank. Two collations may be given to indicate differences between a book's current and original structures, but a single collation can often convey data relevant to both states.

Collectar

A Christian SERVICE BOOK containing the collects (or prayers) for the canonical hours of the DIVINE OFFICE. Collectars often also contain short selections from Scripture and may open with a CALENDAR.

Colophon

An inscription recording information relating to the circumstances of the production of a manuscript or printed book (such as the place, the people involved, and the date). Colophons appear only sporadically in medieval books but were often employed by the Italian HUMANISTS, who tended to include the date. They are generally located at the end of a book.

Colophon decoration

Simple decorative devices, such as dots, commas, ivy leaves (*hedera*), or box surrounds, which serve to highlight the COLOPHON.

Column picture

A MINIATURE that occupies the width of a column (but neither necessarily nor usually its height).

COLUMN PICTURE
Simon Marmion, *The Happy Crowds of the Faithfully Married*. In *Les Visions du chevalier Tondal*, Ghent and Valenciennes, 1475. 36.3 × 26.2 cm (14 5/16 × 10 5/16 in.). Los Angeles, JPGM, Ms. 30 (87.MN.141), fol. 37

COMMENTARY

A discussion or expansion of a text. Commentaries often accompanied the texts they discussed in the form of GLOSSES. See the illustration accompanying GLOSS.

COMMON OF SAINTS

Series of prayers and/or chants for saints who were not accorded individual services, arranged according to categories (martyrs, virgins, etc.).

COMPUTUS TEXTS

Works dealing with the calculation of time. These include Easter tables, almanacs, and other ASTRONOMICAL/ASTROLOGICAL TEXTS, as well as specific treatises such as the Venerable Bede's *De temporum ratione* of 725. Manuscripts of computus texts might include diagrams and, more rarely, figural decoration.

CONJOINT

Conjoint (or conjugate) leaves are two leaves that are or were part of the same BIFOLIUM.

CONTINUATION PANEL

A panel that, like a DISPLAY PANEL, provides a decorative background or frame to the letters following a major INITIAL, which are known as *continuation lettering*. See the illustration accompanying TRANSITIONAL STYLE.

COPT

A Christian descended from the ancient Egyptians. Following the Islamic conquest of the area in 639, the term (Arabic *qibt*, derived from the Greek *aiguptios*) was used to refer to the indigenous population of Egypt, which was predominantly Christian. By the sixteenth century, Westerners used it to distinguish Christian inhabitants from the Muslim majority. The Coptic Church exerted an influence on Europe, especially in the field of eremitic monasticism, and may have contributed certain features to book production, such as COPTIC SEWING and ornamental CARPET PAGES.

COPTIC SEWING

The earliest form of sewing through the center folds of a GATHERING to bind a CODEX. It is a method (with variants) of sewing a book without supports (compare SEWING ON SUPPORTS). Sewn ENDBANDS (with no endband core) might then be added.

Coptic sewing is considered an unsupported sewing structure, since it allows for an unrestricted opening that depends entirely upon the strength of the sewing thread and the integrity of the leather covering material. Coptic sewing structures are generally found on Coptic Egyptian and Ethiopian manuscripts, with similar unsupported sewing structures found in BYZANTINE bindings (though with significant variants in BOARD lacing and endband construction). Among the rare surviving examples of Coptic sewing from the medieval West is the Stonyhurst, or Cuthbert, Gospel, an INSULAR Gospel of Saint John made at Jarrow in the late seventh century for placement in the coffin of Saint Cuthbert.

COPTIC SEWING
Gospel book. Ethiopia,
ca. 1480–1520. 36.5 × 27 ×
11.4 cm (14⅜ × 10⅝ ×
4½ in.). Los Angeles,
JPGM, Ms. 105 (2010.17)

The Coptic-style sewing,
which extends through
tunnels on the edges
of the boards, remains
visible on this uncovered
Ethiopian manuscript.

CORDS

Supporting bands made of twisted bast fiber (traditionally flax or hemp) onto which GATHERINGS are sewn in the binding of a book. At each SEWING STATION, the sewing thread, upon exiting the gathering, is wrapped around the cord before the thread reenters the same hole. If the cord is doubled at the sewing station, a figure-eight stitch is made to ensure a snug attachment to the support before reentering the same hole to continue sewing. The ends of the cords (called *slips*) could be laced into the BOARDS (see CHANNELING and PEGGING) to provide a mechanical board attachment. After covering, the cords are evident as raised bands at intervals along the SPINE of a book. In the late sixteenth century, the taste for flat spine books necessitated cutting out grooves for the cords across the spine folds of the gatherings at each sewing station, into which a single cord would be fitted prior to sewing. See also SEWING ON SUPPORTS.

CORNERPIECE

Shaped metal fittings attached to the corners of a BOARD of a BINDING. A common feature of wood board bindings of the fourteenth and fifteenth centuries, cornerpieces were either cast or hammered to fit around the board edges and serve a protective function. They often included raised BOSSES and might be combined with a CENTERPIECE. The term also refers to a tooled decorative motif in the corners of a board on a binding, or an L-shaped BORDER.

CORRECTION

Systematic emendations to a text undertaken by the SCRIBE who wrote the text or another member of the SCRIPTORIUM called a *corrector*. Corrections take various forms, including simple interlinear and marginal insertions (the latter perhaps marked by a SIGNE-DE-RENVOI), erasures made by scraping with a KNIFE or PUMICE (or washing, in the case of PAPYRUS), cancellations indicated by crossing out or expunctuation (in which points placed beneath a letter or word mark its deletion). The process of correction frequently formed part of the production of a manuscript. More casual corrections might be undertaken by a reader. See the illustration accompanying SIGNE-DE-RENVOI, and, for an example of correction by crossing out and expunctuation, the illustration accompanying BAS-DE-PAGE SCENES.

Couleur changeante

The shading or highlighting of an object (often drapery) in a contrasting color, rather than with a darker or lighter shade of the same color or with black and white. Already in use during the high Middle Ages, the technique was meant to produce a vibrant visual effect. See also MODELING.

Customary

A book describing the customs—the rituals accompanying liturgical services or monastic discipline, for example—of an ecclesiastical establishment. A customary is also known as a *consuetudinary* or *liber ordinarius.*

Cut leather

A technique for decorating the leather covering material of a BINDING in which a design is cut into dampened leather to create a three-dimensional relief. Often described by its French name, *cuir-ciselé*, cut-leather decoration was practiced primarily in southeastern Germany and Spain in the fifteenth century.

Cutting

A piece, often a MINIATURE or painted INITIAL, cut out of an illuminated manuscript, generally for commercial or collecting purposes. The practice of cutting painted decoration from manuscripts was largely a phenomenon of the eighteenth and nineteenth centuries. Once medieval manuscripts became readily available on the open market in the nineteenth century, cuttings were collected for their independent aesthetic value and often mounted into albums, pasted into a collage, or framed for display on a wall.

CUTTING
Lippo Vanni, initial *I: A Martyr Saint*. Detached leaf from an antiphonal, Siena, third quarter of the fourteenth century. 30.2 × 11.5 cm (11⅞ × 4½ in.). Los Angeles, JPGM, Ms. 53 (93.MS.38), recto

Some connoisseurs and collectors removed illuminations from manuscripts by assiduously trimming away all traces of the surrounding text and following the contours of the painted design exactly to shape, as in this example.

Damp-fold drapery

A term coined in the mid-twentieth century to refer to a style of depicting drapery in which the material appears to cling to the body like wet cloth. The drapery folds not only articulate the human figure but also, being sinuous and rhythmical, produce a decorative effect. The style, ultimately derived from BYZANTINE art, is found in the West beginning in the twelfth century and is an international feature of ROMANESQUE art. Three variations of damp-fold drapery have been noted: a style composed of concentric lines, particularly favored in Burgundy in the twelfth century; nested V folds, in which planes of drapery of ovoid or pear shape terminate in a series of Vs—a widespread convention for rendering hanging drapery; and the clinging curvilinear style, characterized by S-shaped lines, which enjoyed its greatest popularity in England, becoming something of a hallmark of English art around 1140–70. This last style is often termed the *Bury Bible figure style* after one of its earliest representatives.

Decorated initial

An INITIAL composed of nonfigural, nonzoomorphic decorative elements.

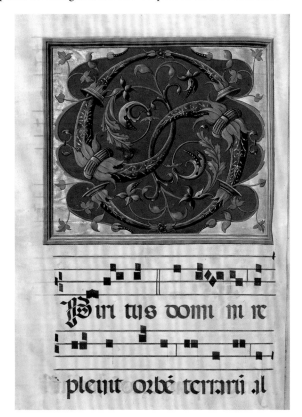

Decorated initial
Antonio da Monza, decorated initial *S*. In a gradual, Rome, late fifteenth or early sixteenth century. 64.1 × 43.5 cm (25¼ × 17⅛ in.). Los Angeles, JPGM, Ms. Ludwig VI 3 (83.MH.86), fol. 62v

Decorated letter

Any embellished letter could be termed *decorated*. In practice, decorated letters almost always occur as INITIALS.

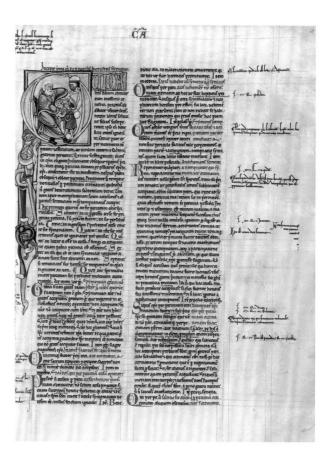

DECRETALS

Initial *Q: An Abbot Receiving a Child.* In Gratian, *Decretum,* Paris or Sens, ca. 1170–80. 44.3 × 29.1 cm (17⁷⁄₁₆ × 11⁷⁄₁₆ in.). Los Angeles, JPGM, Ms. Ludwig XIV 2 (83.MQ.163), fol. 63

DECRETALS

Collections of papal rulings of local or universal application, often made in response to an appeal and frequently relating to matters of religious discipline. Manuscripts of decretals may be illuminated with scenes germane to the text or with scenes designed to relieve the text, such as BAS-DE-PAGE SCENES narrating SAINTS' LIVES or amusing scenes from daily life and GROTESQUES.

The earliest decretals were simple collections of papal decrees and letters. Among the most notable are the *Collectio Dionysiana* of Dionysius Exiguus, compiled in the early sixth century; Pope Hadrian I's collection, sent to Charlemagne in 774 (*Collectio Dionysio-Hadriana*), which became the authoritative Frankish text on canon law; the sixth-century Spanish collection associated with Isidore of Seville (*Hispana collectio*); the *False Decretals of Pseudo-Isidore*, compiled in France in the ninth century; the Italian *Anselmo dedicata collectio* (ca. 900), the tenth-century *Collectio canonum* of Abbo of Fleury; Regino of Prüm's collection of canon laws; the *Decretum* of Burchard of Worms, begun ca. 1012; and the canon law collections of Ivo of Chartres (d. 1115/6). Gratian's *Decretum* of ca. 1120–40 summarized older papal letters and conciliar decrees and became the most important law book of the twelfth century. It marked the end of the traditional form of collection, giving rise to the greatest period of legal scholarship in the Roman Church. Later collections include the *Quinque compilationes antiquae*

(1226 or 1227); the *Decretals* of Pope Gregory IX of 1234, an important new edition of canon law; the *Liber sextus* of Pope Boniface VIII of 1298; and the *Constitutiones Clementinae* of Pope Clement V of 1317. Decretals generated a number of COMMENTARIES, which often appear as marginal GLOSSES.

DEDICATION MINIATURE See PRESENTATION MINIATURE.

DEVICE

A figure or design, often accompanied by a MOTTO, used to identify an individual, family, or nation.

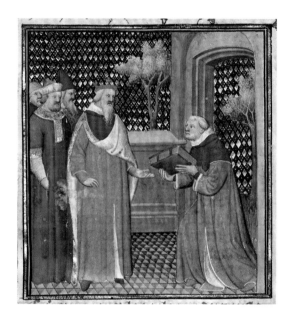

DIAPER PATTERN
The Presentation of the Book to a King. In Giovanni Boccaccio, *Des cas des nobles hommes et femmes*, Paris, ca. 1415. 42 × 29.6 cm (16⁹⁄₁₆ × 11⅝ in.). Los Angeles, JPGM, Ms. 63 (96.MR.17), fol. 1 (detail)

DIAPER PATTERN

A repetitive geometric pattern, from the French *diapré*, meaning "variegated." Although used as early as the eleventh century, it is a background especially characteristic of GOTHIC illumination.

DIGEST

A compilation of legal rules and statutes. The earliest digests were systematic, comprehensive treatises on Roman law, composed by classical Roman jurists. Medieval copies of these Roman digests were sometimes GLOSSED and illuminated, with scenes either related to the text or of an extraneous and often amusing character.

DIMENSIONS

When expressing the size of a manuscript, the dimensions of a leaf (height × width) are given. Manuscripts were often trimmed at some point in their history, and it is therefore useful to give the dimensions of the written space as well. The RULING can conveniently be measured for this purpose. The metric system is preferred.

Diminuendo

A decorative device that makes the transition in scale from an enlarged painted INI-
TIAL to the main SCRIPT used for the text. A diminuendo is accomplished by gradu-
ally reducing the height of a few lines or letters following the initial. The device was
particularly popular with INSULAR scribes.

Diplomatics

The study of documents and records, their form, language, and SCRIPT. The term
diplomatics (in British usage, *diplomatic*) was coined in the seventeenth century and
initially embraced PALEOGRAPHY.

Display panel

A decorative panel containing DISPLAY SCRIPT.

Display script

Decorative SCRIPT, generally incorporating higher-grade letter forms and sometimes
employing a variety of colors. Display script is often used, along with an enlarged INI-
TIAL, to emphasize major textual openings. See the illustration accompanying INHAB-
ITED INITIAL.

Diurnal

A book, sometimes called a *journal*, used in the celebration of the DIVINE OFFICE, but
in principle containing only the daytime offices (lauds, prime, terce, sext, none, ves-
pers, and compline). Its layout is like that of the BREVIARY or ANTIPHONAL. The com-
panion volume, the *nocturnal*, in principle contains only the predawn office of matins.
In practice, however, the contents of manuscripts termed *diurnal* and *nocturnal* vary.

Divine Office

Christian daily devotions celebrated by members of religious orders and the clergy.
Each prayer service, or office, consists mainly of the recitation of Psalms and lessons
from Scripture. Hymns and antiphons, as well as responsories, canticles, collects, and
other elaborations were also included. By the sixth century, the cycle of eight canonical
hours for the celebration of the Divine Office had been fixed (times varying depending
upon the time of year and, hence, the rising and setting of the sun): matins (approxi-
mately 2:30 a.m.), lauds (approximately 5:00 a.m.), prime (approximately 6:00 a.m.),
terce (approximately 9:00 a.m.), sext (approximately noon), none (approximately 3:00
p.m.), vespers (approximately 4:30 p.m.), and compline (approximately 6:00 p.m.).

The Divine Office was arranged so that the complete PSALTER could be recited
each week, and much of Scripture in the course of a year. During the Middle Ages,
however, the celebration of saints' feast days and readings from their lives (see MAR-
TYROLOGY) interfered with this structure. Along with the MASS, the Divine Office
forms the basis of Christian LITURGY.

DNA ANALYSIS

The study of genetic material from animal-based products, such as PARCHMENT and animal glues. DNA analysis can determine the species (see also PROTEOMICS) and the sex of the animal as well as the genetic relationship between animals (i.e., animal kinship). For sheets of parchment, for example, DNA analysis may help determine whether two separated leaves come from the same, or related, animals.

DONOR

A person who donates an object—and often commissions it as well—to an institution. It is sometimes possible to identify the donor or owner of a book through the presence of an inscription, armorial bearings in images or margins, or a MOTTO. Portraits of the donor (often STYLIZED, although some true portrait likenesses do occur) are found throughout the Middle Ages and became increasingly popular from the thirteenth century on. Such portraits might show the donor kneeling before the Virgin and Child or receiving or presenting a commissioned work.

DRAFTSMAN

The person responsible for laying out the design of an image in a drawing, who may or may not be the artist responsible for the painting. See the illustration accompanying UNDERDRAWING.

DROLLERY

An amusing figure, often of a GROTESQUE character. Drolleries appear throughout the history of book ILLUMINATION, from INSULAR works such as the Book of Kells to late medieval manuscripts such as the PRAYER BOOK of Charles the Bold, but they were particularly popular from the thirteenth to the fifteenth century.

DROLLERY
Marginal drollery, or *Ass Playing a Harp*. In an antiphonal, northeastern France or Flanders, ca. 1260–70. 48.1 × 34.9 cm (18¹⁵⁄₁₆ × 13¾ in.). Los Angeles, JPGM, Ms. 44/Ludwig VI 5 (92.MH.22), fol. 115 (detail)

DRY POINT See HARD POINT.

EARLY CHRISTIAN

The Early Christian period extends from the time of Jesus to around 600, when Pope Gregory the Great (ca. 540–604) established a strong, independent Western Church. The culture of the early BYZANTINE Empire is included under this heading. The Early Christian period (which overlaps with LATE ANTIQUITY) witnessed the beginnings of substantial book decoration.

EMBLEM (PL. EMBLEMATA)

A pictorial ALLEGORY or symbolic representation, usually accompanied by a MOTTO. An emblem can serve as an identifying sign for a person, family, or nation.

ENDBANDS

Sewn attachments that consolidate the HEAD and TAIL of a book's SPINE. If laced into the BOARDS, endbands can also strengthen the attachment of the boards. With cores generally of ALUM-TAWED SKIN, hemp or linen CORD, or PARCHMENT (with cane and rolled PAPER used at later dates), endband sewing threads are woven around the core and tied down through the centers of the GATHERINGS at or near the KETTLE STITCH. Multicolored threads (including undyed thread) are often used for the sewing of the endband to create a decorative pattern. An endband at the head of the spine is often referred to as a *headband*.

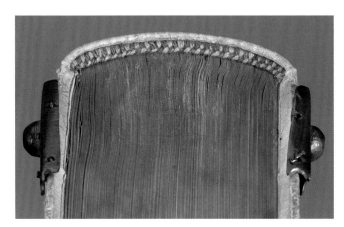

ENDBANDS
Endband. Peter Comestor, *Historia scholastica*, Austria, ca. 1300. 34.3 × 24.3 cm (13½ × 9⁹⁄₁₆ in.). Los Angeles, JPGM, Ms. Ludwig XIII 1 (83.MP.144) (detail)

This endband was sewn with an alternating pattern of blue-dyed and undyed flax threads.

ENDPAPERS

Two or more blank or decorated leaves added by the BINDER between the FLYLEAF and BOARD at the beginning or end of a book. Depending upon the binding's construction, the endpaper nearest the board might be glued down to the inside of the cover to form a PASTEDOWN. Since the introduction of endpapers postdates the medieval era, decorated endpapers are likely to be found in manuscripts that have been bound (or rebound) in the late sixteenth century and later.

EPISTOLARY

A Christian SERVICE BOOK containing the Epistle readings for the MASS arranged according to an annual cycle of their use, usually beginning with Advent, the season of preparation for Christmas. The Epistle reading is generally taken from the New Testament Epistles but is sometimes drawn from other parts of the BIBLE. At high mass the Epistle was read by a subdeacon.

EVANGELARY See GOSPEL BOOK.

EVANGELISTARY See GOSPEL LECTIONARY.

EVANGELIST PORTRAIT

A representation of one of the purported authors of the Gospel accounts of the life of Christ (Saints Matthew, Mark, Luke, and John). The evangelists were often depicted as SCRIBES from the EARLY CHRISTIAN period on. They might be shown accompanied by, or conflated with, the EVANGELIST SYMBOLS. Other types of depictions of the evangelists include scenes of Saint John on Patmos (found sometimes in manuscripts of the

EVANGELIST PORTRAIT
Saint John. In a Gospel book, Ethiopia, ca. 1504–5. 34.5 × 26.5 cm (13⁹⁄₁₆ × 10⁷⁄₁₆ in.). Los Angeles, JPGM, Ms. 102 (2008.15), fol. 215v

APOCALYPSE and in BOOKS OF HOURS) and of Saint Luke painting or drawing a portrait of the Virgin and Child (an image, ultimately of BYZANTINE derivation, which is encountered most often in books of hours).

EVANGELIST SYMBOL

Symbols of the evangelists derived from a vision of the Old Testament prophet Ezekiel and the vision of Saint John the Divine in the APOCALYPSE. In the West, the beasts of Saint John's vision were usually associated with the evangelists as follows: Matthew with the man; Mark with the lion; Luke with the ox or bull calf; and John with the eagle. The symbols may appear with or without wings, halos, and books. They may be included in EVANGELIST PORTRAITS, or they may be conflated with human figures to form zoo-anthropomorphic evangelist symbols. See the illustration accompanying ZOO-ANTHROPOMORPHIC INITIAL.

EVANGELIST SYMBOL
Saint John the Evangelist Writing. Detached leaf from an Apocalypse, Hessen or Cologne, ca. 1340–50. 45.4 × 30.5 cm (17⅞ × 12 in.). Los Angeles, JPGM, Ms. 108 (2011.24), verso

In the manuscript of the Apocalypse from which this leaf comes, the figure shown in the author portrait is identified by an inscription as "John the Evangelist" and is accompanied by John's symbol, the eagle.

Exemplar

A book from which another is copied or a text that has been copied. See also PECIA SYSTEM.

Ex libris inscription

An inscription that records a book's inclusion in a library, whether private or institutional. Such inscriptions offer valuable evidence of a manuscript's PROVENANCE. Bookplates also carry *ex libris* (Latin meaning "from the books") information.

EX LIBRIS INSCRIPTION
Ex libris inscription. In a Bible known as the Marquette Bible, Lille, ca. 1270. Los Angeles, JPGM, Ms. Ludwig I 8 (83.MA.57), vol. 1, fol. 99 (detail)

This inscription, added to the volume in the fifteenth century, declares that the book belongs to the abbey at Marquette, a house of Cistercian nuns in northern France.

Explicit

The closing of a textual unit, from the Latin *explicitus*, meaning "unfolded" or "unrolled." In catalogs of manuscripts, the INCIPIT and explicit of constituent texts are often cited to identify them.

Expressionistic style

A style of painting that conveys a sense of heightened emotionality and often entails a MANNERED or exaggerated treatment of forms. An expressionistic approach was especially prevalent in phases of BYZANTINE and English art and in some German ILLUMINATION.

Exultet roll See ROLL.

Fiber optic reflectance spectroscopy (FORS) See REFLECTANCE SPECTROSCOPY.

Flemish See BURGUNDIAN.

Flesh side

The side of an animal's hide or skin that originally faced the animal's body, reverse of the HAIR SIDE. Although depending partly upon the animal species and the PARCHMENT preparation method used, the flesh side is generally whiter than the hair side. The flesh side of leather is opposite the *grain side*.

Flyleaf

A blank leaf (typically the same material as the text leaves) at the beginning and end of the text that protects the text from damage. A flyleaf can be connected (called CON-JOINT) to a text page, or be conjoint with the PASTEDOWN when no ENDPAPERS are present. Flyleaves often carry PEN TRIALS and inscriptions that sometimes relate to the manuscript's PROVENANCE.

Folio

A leaf of a CODEX, one half of a BIFOLIUM. The front and back of a folio are referred to as the RECTO and VERSO, respectively. The numbering of leaves, as opposed to pages, is termed *foliation* and is commonly found in manuscripts. "Folio" and "folios" are often abbreviated as *f.* and *ff.* The term can also be used to denote a large volume size.

Fore edge

The edge of a book opposite the SPINE. The fore edge sometimes carries BOOKMARKER tabs, might be decorated with GAUFFERING or painting, and can bear an inscribed title (especially if once shelved horizontally). Fore edges of BOARDS might have one or more CLASP AND CATCH mechanisms or another means to help keep the manuscript closed and protected. See also STRAP AND PIN.

Frame ruling

RULING that provides a frame to contain the text without a series of horizontal lines to guide each line of writing. See also MISE-EN-PAGE.

Fretwork

Ornament featuring a repeated rectilinear geometric pattern.

Fully painted illumination

An ILLUMINATION that has been rendered throughout in PIGMENTS rather than wholly or partly in line or tint, with reserve PARCHMENT forming an element of the image (see OUTLINE DRAWING and TINTED DRAWING).

Furnishings See METAL FURNISHINGS.

Gallnut See OAK GALL.

Gathering

A booklet (of nested folded BIFOLIA) in a CODEX. Gatherings are frequently referred to as *quires*, properly speaking, a term for gatherings of four bifolia (= 8 leaves/16 pages), the most common sort of gathering in medieval books. The numbering of gatherings, which began in LATE ANTIQUITY, consists of numbers written on a gathering (usually on its final VERSO) to facilitate arrangement during BINDING.

Leaf signatures are numbers and/or letters written in a gathering to facilitate the arrangement of its internal components. These were at first ad hoc, but beginning

around 1400 they might follow a system: for example, *ai–aiv* could be written on the first four leaves of the first gathering, *bi–biv* on the first four leaves of the second gathering, and so on.

Gauffering

A method of edge treatment in which a BINDER impresses heated hand or roll tools onto the usually gilded HEAD, TAIL, and FORE EDGE of a bound book. Gauffered edges create a rich, decorative effect to a book's edges when closed.

Gauffering
Tail edge. Bible known as the Abbey Bible, Bologna, ca. 1250–62. 27 × 19.7 cm (10⅝ × 7¾ in.).
Los Angeles, JPGM, Ms. 107 (2011.23)

The gilded edges of this Bible have been decorated with an elaborate gauffered foliate design, made in relief by repeatedly impressing a pointed tool into the tightly compressed edges of the closed book.

Germanic

Germanic-speaking peoples settled in what had been the western Roman Empire, forming a number of successor states (such as Francia, ANGLO-SAXON England, Visigothic Spain, and Ostrogothic and Lombardic Italy). They brought with them a vigorous art style, characterized by zoomorphic ornament and INTERLACE patterns. They made a major contribution to the development of INSULAR and PRE-CAROLINGIAN art and fostered regional developments in SCRIPT.

Gesso

A thick, water-based priming material, typically consisting of gypsum (calcium sulfate), plaster, or CHALK mixed with a glue. Gesso is used in manuscript ILLUMINATION as a GROUND for the application of metal leaf, since gesso forms a raised surface ideal for BURNISHING. Methods of gesso preparation varied. See also BURNISHING and GILDING.

Gilding

The application of metal leaf (typically gold or silver) to a surface. In medieval ILLUMINATION, gold in powdered form was applied with a BRUSH or pen for use in linear details and in CHRYSOGRAPHY, or it was applied in leaf form. The metal leaf could be laid down on an area to which a BINDING MEDIUM such as GLAIR or gum had been applied (called *mordant gilding*). When laid on a raised white GESSO or other colored

GILDING

Probably workshop of
Ulrich Schreier, initial
B: David in Prayer. In
a diurnal, Salzburg or
Vienna, ca. 1485. 17.6 ×
13 cm (6¹⁵⁄₁₆ × 5⅛ in.).
Los Angeles, JPGM, Ms.
Ludwig IX 14 (83.ML.110),
fol. 17v (detail)

The gilded background
of burnished gold leaf in
this initial is embellished
with swirling incised
foliate designs drawn
with a stylus, dotted
floral motifs made by
repeated impressions with
a pointed tool, and tooled
flower impressions made
by a carved punch.

base layer (called *bole* if containing orange-brown iron earth), the gold leaf takes on the tonality of the GROUND. Gesso grounds enable the gilded surface to be polished to a high sheen (called BURNISHING) and embellished with incised or tooled designs. Gilding formed the first stage in the painting processes of illumination, since handling gold leaf can be difficult and the gilded area might require trimming with a KNIFE. The gilding of a manuscript illustration was carried out by the illuminator or by a specialist. For gold applied to the leather covering material on a binding, see TOOLING.

GIRDLE BOOK

A small portable book designed to be attached to a belt (or girdle). Girdle books were most often BOOKS OF HOURS or PRAYER BOOKS carried for devotional purposes, especially by wealthy women. They were particularly popular during the fifteenth and sixteenth centuries. Medical and prognostication manuals were also worn on the belt. See also VADE MECUM.

GLAIR

Clarified egg white used as a BINDING MEDIUM in paint.

GLOSS

A word or words commenting on, elucidating, or translating those of the main text. Glosses were often written in the margins or between the lines. The term is also used as a nickname for the *Glossa ordinaria*, an authoritative commentary on the BIBLE compiled in the twelfth century that circulated widely.

GLOSS

Text page. Leaf from the
Glossa ordinaria on Luke,
France, ca. 1200. 37 × 25 cm
(14⅝ × 9⅞ in.). Kalamazoo,
Western Michigan Univer-
sity Libraries, Ms. 141, recto
(detail)

Almost all the text on this
page comprises glosses
written half the size of
the biblical text, which
is confined mostly to
the middle column. The
placement of the text on
the page was planned in
advance so that every gloss
would be immediately
proximate to the word or
phrase of the biblical text it
explicates.

GOSPEL BOOK

A CODEX containing the full text of the Gospels (the four accounts of Christ's life attributed to Saints Matthew, Mark, Luke, and John), often accompanied by introductory matter such as the prefaces of Saint Jerome, Eusebius's CANON TABLES, and chapter lists (*capitula*). In LATE ANTIQUITY, what had been a practice of continuous reading from the Gospels at MASS on Sundays (*lectio continua*), with specific passages prescribed only for major feasts, was replaced by the assignment of a specific passage (*pericope*) for each day. Capitularies, which listed pericopes by their INCIPITS and EXPLICITS and were arranged in the order of liturgical year, were sometimes included in Gospel books.

A number of sumptuous early medieval Gospel books (many connected with important cults and PATRONS) feature CARPET PAGES and EVANGELIST PORTRAITS. Beginning in the late eighth century, Gospel books were partially replaced in liturgical use by GOSPEL LECTIONARIES, containing the Gospel readings for the year in liturgical order. See the illustrations accompanying BYZANTINE, CANON TABLES, EVANGELIST PORTRAIT, and ROMANESQUE.

Gospel lectionary

A book that contains the Gospel readings for the MASS, arranged according to the liturgical year. Also known as a *pericope book*, the Gospel lectionary was a more practical volume for use in the celebration of mass than a GOSPEL BOOK.

Gospel lectionary
Decorated initial *L*.
In a Gospel lectionary,
St. Gall or Reichenau,
ca. late tenth century.
27.8 × 19.2 cm (10¹⁵⁄₁₆ ×
7⁹⁄₁₆ in.). Los Angeles,
JPGM, Ms. 16
(85.MD.317), fol. 128

Gothic

A term used by the art critic Giorgio Vasari in the sixteenth century with reprobation to describe the art produced between ANTIQUITY and the RENAISSANCE. It is now used to describe the non-HUMANISTIC scripts used in writing literary texts in the thirteenth through sixteenth centuries. It is also used to denote a period of Western painting that began ca. 1200 and ended sometime between ca. 1300 and the early sixteenth century, depending on the region in question and the rapidity of its response to the Renaissance. There were chronological and regional stylistic differences during this period, but the underlying, international characteristics of Gothic ILLUMINATION include a love of the courtly and of the GROTESQUE, which might coexist; an interest in an essentially NATURALISTIC depiction of the figure (although a penchant for courtly elegance, along with MANNERED or EXPRESSIONISTIC STYLES could intrude); and a decorative

approach to INITIALS, frames, and backgrounds (which during the late Middle Ages gave way to a growing interest in landscape and perspective). In the Gothic period, the range of books produced became increasingly diversified (varying from biblical volumes and BOOKS OF HOURS to SCHOOL BOOKS, ROMANCES, and almanacs). Moreover, SECULAR PRODUCTION and consumption increased, with cities emerging alongside and then surpassing monasteries as the most prolific production centers.

GOTHIC
Scenes from the Life of Noah. In a psalter known as the Wenceslaus Psalter, Paris, ca. 1250–60. 19.2 × 13.3 cm (7⁹⁄₁₆ × 5¼ in.). Los Angeles, JPGM, Ms. Ludwig VIII 4 (83.MK.95), fol. 9v

GRADUAL

The sung response with verse to the Epistle reading that constitutes one part of the MASS. The name derives from the practice of singing the gradual on the steps of the raised pulpit. The term is used for the principal CHOIR BOOK used in the mass. Arranged according to the liturgical year (with TEMPORALE, SANCTORALE, and COMMON OF SAINTS), a gradual contains (in addition to the graduals themselves) introits, tracts, alleluias, offertories, and communions. The introits—the first sung elements of the mass—were often introduced by HISTORIATED INITIALS. The initial for *Ad te levavi*, the introit for the first Sunday in Advent, was usually the most elaborate.

GRISAILLE

Lieven van Lathem, *Miracle of the Adulterous Woman's Repentance*. Detached leaf from Jean Miélot, *Miracles de Nostre Dame*, probably Ghent, ca. 1460. 13.2 × 17.8 cm (5³⁄₁₆ × 7 in.). Los Angeles, JPGM, Ms. 103 (2009.41), recto

GRISAILLE

Monochrome painting, also called *camaïeu*, that generally employs shades of gray, from the French *gris*, meaning "gray." Grisaille can be executed in a black PIGMENT (such as a carbon-based lampblack) and an inert white pigment. It was especially popular in the second half of the fourteenth century and in the fifteenth century. Semi-grisaille, with figures in shades of gray and landscape elements in color, characterized ILLUMINATION at the court of King Charles V of France (r. 1364–80).

GROTESQUE

A hybrid, often comic, figure, perhaps combining elements from various human and animal forms. Grotesques often bear no obvious relationship to the texts they embellish, although they can carry a commonly understood meaning derived, for example, from BESTIARY-related texts. They were especially popular in GOTHIC art. See also DROLLERY.

GROUND

A preparation layer applied to a support for writing, drawing, painting, or gilding. Often called a *priming layer* in easel painting, grounds in manuscript ILLUMINATION were mostly confined to the areas to be gilded (compare GESSO and GILDING). The BYZANTINE tradition stands as the exception, as grounds (including GLAIR, flax mucilage, or a white ground material such as gypsum, CHALK, or white lead) were often applied to the entire PARCHMENT or PAPER surface to be illuminated.

Guard

A long strip of PARCHMENT or PAPER, folded lengthwise, that is inserted into the center of a GATHERING or wrapped around the SPINE edge of a gathering to reinforce the fold for sewing, especially in early paper manuscripts. A pair of single leaves can be attached by a guard to create a made-up BIFOLIUM.

Guide letter

A letter written (usually by a SCRIBE) to tell another scribe or an ILLUMINATOR what colored or painted letter to supply. Indications concerning which color was to be used (color notes) and fuller notes relating to the subject matter of an image might also be given, often in HARD POINT or METALPOINT to render them less obtrusive.

Gutter

The place where BIFOLIA of writing support material, usually PARCHMENT in the Middle Ages, are folded and meet the SPINE inside a CODEX.

Gymnastic initial

An INITIAL composed of lively, acrobatic human and/or animal figures. Gymnastic decoration can occur in other contexts as well.

Hagiography See SAINTS' LIVES.

Hair side

The outer surface of an animal skin that once carried the hair. On a sheet of PARCHMENT, the hair side sometimes has a darker tonality than the FLESH SIDE and may exhibit the speckled traces of hair follicles in patterns that can help characterize the animal species. Parchment preparation methods, such as surface scraping or the application of a GROUND (as in BYZANTINE manuscripts), can obliterate the hair follicles, making the hair side and animal type difficult to detect. The hair side of leather is called the *grain side*.

Half sheet See SINGLETON.

Hard point

A pointed implement of metal or bone (often a STYLUS) used for RULING, drawing, and annotation. A hard point leaves a narrow impression on the writing surface and results in a raised ridge on the reverse side of the page, rather than leaving a graphic mark.

Head

The top edge of a manuscript.

HEADBAND See ENDBANDS.

HEADPIECE

A panel of ornament that stands at the beginning of a text. The use of headpieces was inherited by the medieval West from LATE ANTIQUE book production and enjoyed particular popularity during the RENAISSANCE.

HEADPIECE
Decorated text page.
In a Gospel book,
Constantinople,
ca. late thirteenth
century. 21 × 14.9 cm
(8¼ × 5⅞ in.). Los
Angeles, JPGM, Ms. 65
(98.MB.151), fol. 104

HERALDRY

The design, display, and study of armorial bearings. Heraldry developed in the West in the twelfth century and evolved along with concepts of nobility and chivalry during the thirteenth and fourteenth centuries. Military identification symbols had been known in ANTIQUITY, but the systematic use of coats of arms emerged as an adjunct to medieval feudalism, serving to identify the allegiance of knights. Heraldic DEVICES were employed by secular society, by the Church, and by guilds and corporations. By the fourteenth century, strict rules concerning the significance of different components of a coat of arms were in full force.

The language of heraldry is French. There is an elaborate vocabulary for the *blazoning* (or describing) of a shield, involving its *tinctures* (colors), *charges* (geometric patterns, called *ordinaries*, and the figures or objects depicted), and the way in which the arms are "differenced" to indicate collateral branches of a family. Helmets and

HERALDRY

Franco dei Russi, initial *E: David Lifting Up His Soul to God*. Detached leaf from the Antiphonal of Cardinal Bessarion, Ferrara, ca. 1455–61. 71.1 × 51.4 cm (28 × 20¼ in.). Los Angeles, JPGM, Ms. 99 (2007.30), recto and detail

The coat of arms of Cardinal Bessarion (d. 1472) is found in the border decoration of the opening page of an illuminated choir book that he commissioned.

supporters (figures such as the lion and the unicorn supporting the shield) also obey complex rules and nomenclatures. Many illuminated genealogies, pedigrees, and heraldic manuals were produced during the late Middle Ages. The occurrence of heraldic devices within manuscripts also yields valuable evidence concerning their ownership.

HERBAL

A text dealing with plants and their properties, often medicinal. Medieval herbals were frequently illustrated.

The study of plants formed part of natural philosophy in ANTIQUITY. Among the major authors of botanical texts written from the fourth century BCE to the fourth century CE are Aristotle, Theophrastus (*Historia plantarum*), Dioscorides (*De materia medica*), and Pseudo-Apuleius (*Herbarium*). Many of these works were probably illustrated in Antiquity. Southern Italy (especially at Squillace, Montecassino, and Salerno) preserved the classical interest in botany and the medicinal use of plants into the Middle Ages. The CAROLINGIAN and ANGLO-SAXON worlds did much to perpetuate interest in several botanical texts (notably the works of Dioscorides and Pseudo-Apuleius); England produced the first VERNACULAR translation of the *Herbarium*, ca. 900. These early medieval copies contain cycles of illustrations that seem primarily to represent copies of antique cycles. It is clear from the errors in these depictions that the illuminators had no direct knowledge of some of the plants, and they retained images of classical deities such as Diana, Asclepius (god of medicine), and Mercury as well as the centaur Chiron, legendary teacher of Asclepius.

Illuminated herbals continued to be produced throughout the Middle Ages, primarily as LIBRARY BOOKS, and their illustrations became progressively more STYLIZED.

The Arabic-speaking world also preserved—and expanded—knowledge of classical botany, which from the late eleventh century on was transmitted to the West. At the medical school of Salerno in the mid-twelfth century, the *Circa instans*, containing remedies, or *simples*, from Latin and Arabic sources, was compiled. Some manuscripts of the *Circa instans* (also known as the *Liber simplici medicina* and *Secreta salernitana*) and the slightly later *Tacuinum sanitatis*, from northern Italy, have illustrations of plants based on the direct observation of nature rather than on images in earlier herbals. This more scientific trend was perpetuated in works such as the *Herbolario volgare* (*Popular Herbal*, an Italian translation of an Arabic treatise by Serapion the Younger) and initiated the RENAISSANCE tradition of naturalistically illustrated herbals.

HERBAL
Sorrel, Shepherd's Purse, and White Briony. In Bartholomaei Mini de Senis, *Tractatus de herbis*, Southern Italy (Salerno), ca. 1280–1310. 36 × 24 cm (14 3/16 × 9 7/16 in.). London, The British Library, Ms. Egerton 747, fol. 16v

HEXATEUCH

The first six books of the Christian Old Testament, which were sometimes contained in a single, separate volume.

HIBERNO-SAXON See INSULAR.

Hierarchy

A system for arranging elements in a series according to formal or functional degrees of importance. A hierarchy can be applied to decorative elements, which may vary in content to include MINIATURES, TITLE PIECES, HEADPIECES, BORDERS, and painted INITIALS. Each illuminated manuscript displays its own hierarchy of decoration, with various levels to indicate the relative importance of sections of text and to highlight textual divisions.

Historiated initial

A letter containing an identifiable scene or figures, sometimes relating to the text. Historiated initials, first encountered in INSULAR illumination of the first half of the eighth century, became a popular feature of medieval ILLUMINATION. BORDERS can also be historiated.

Historiated initial
Stefano da Verona, initial *A: Pentecost.* Cutting from an antiphonal, Lombardy, ca. 1430–35. 11.9 × 12.5 cm (4¹¹⁄₁₆ × 4¹⁵⁄₁₆ in.). Los Angeles, JPGM, Ms. 95 (2005.28), recto

History texts See CHRONICLE.

Homiliary

A book containing homilies (discussions of biblical passages) arranged according to the ecclesiastical year.

Horae See BOOK OF HOURS.

HUMANISM

Initial *G: Julius Caesar on Horseback*. In Gaius Julius Caesar, *Bellum gallicum*, Florence, ca. 1460–70. 32.7 × 23 cm (12⅞ × 9¹⁄₁₆ in.). Los Angeles, JPGM, Ms. Ludwig XIII 8 (83.MP.151), fol. 2

HUMANISM

A system of study characterized by a revival of classical learning that originated in Florence in the late fourteenth century and was an important component of the Italian RENAISSANCE. As an adjunct to this revival, the conscious reformation of SCRIPT and book design was promoted during the fourteenth and fifteenth centuries by Italian humanists such as Petrarch, Poggio Bracciolini, Niccolò Niccoli, and Coluccio Salutati. Florence and Rome were at the forefront of humanistic book production, with other centers such as Milan and Bologna remaining more conservative. Nonetheless, the force of the movement was felt throughout Europe by the late fifteenth century.

Humanistic script was inspired by Caroline minuscule (see CAROLINGIAN) and served as a model for the earliest Italian typefaces. The decoration of humanistic manuscripts, including the WHITE VINE-STEM border, features motifs derived from earlier medieval manuscript art and the art of classical ANTIQUITY.

Hymnal

A book or section of a book, also called a *hymnary*, containing the texts of metrical hymns sung in the DIVINE OFFICE and arranged according to the liturgical year. A hymnal could be included in a PSALTER or ANTIPHONAL. Its contents were eventually incorporated into the BREVIARY.

Hyperspectral imaging See MULTISPECTRAL AND HYPERSPECTRAL IMAGING.

Icon

In the term's broadest sense, a likeness of a sacred personage or subject that is venerated, from the Greek meaning "image." Icons originated in the EARLY CHRISTIAN Church, typically in the form of small paintings on wood.

Iconography

In common usage, the subject of a picture; in a specialized sense, the study of the meaning of images, including their symbolic content. The eagle, for example, may be understood as a symbol of the evangelist Saint John (see EVANGELIST SYMBOL).

Illumination

The embellishment of a MANUSCRIPT, from the Latin *illuminare*, meaning "to enlighten or illuminate." Medieval manuscripts were embellished with precious metals that "light up" as the pages are turned.

Illuminator

An artist producing ILLUMINATION. The illuminator could, on occasion, also be the SCRIBE of a given manuscript. In LATE ANTIQUITY, illuminators constituted a professional class. In the early Middle Ages, they usually worked in an ecclesiastical SCRIPTORIUM as part of a team or were attached to a court. There were probably also some itinerant illuminators in this period. Following the rise of the universities around 1200, illuminators were generally based in urban centers, although many monastic scriptoria, with resident or outside illuminators, continued to function. In the cities, illuminators often lived in the same neighborhood and frequently collaborated (see WORKSHOP and SCHOOL OF ILLUMINATION).

Illuminators could be male or female. They might be members of monastic or minor clerical orders; after 1200, members of the LAITY increasingly took up the profession. By the late Middle Ages, most illuminators were lay people. Illuminators continued to practice their art after the introduction of printing in the fifteenth century, embellishing both manuscripts and early printed books and often working in the field of professional CALLIGRAPHY.

ILLUSIONISTIC PAINTING

Painting that successfully creates the appearance of three-dimensional objects in a three-dimensional space on a two-dimensional surface.

ILLUSIONISTIC PAINTING
Master of James IV of
Scotland, *Office of the
Dead*. In a book of hours
known as the Spinola
Hours, Bruges and Ghent,
ca. 1510–20. 23.2 × 16.7 cm
(9⅛ × 6⁹⁄₁₆ in.).
Los Angeles, JPGM,
Ms. Ludwig IX 18
(83.ML.114), fol. 185

IMPRESSIONISTIC STYLE

Painting style that suggests the optical appearance of three-dimensional objects in three-dimensional space. In manuscript ILLUMINATION, impressionistic styles often feature sketchy lines that suggest, but do not define, forms in space and may imply movement.

INCIPIT

The opening words of a text, from the Latin *incipere*, meaning "to begin." The incipit of a medieval text, rather than a title, is often used, sometimes together with the EXPLICIT, to identify it.

INCIPIT PAGE

The first page of a major section of text that is embellished with a large INITIAL or monogram and DISPLAY SCRIPT.

INCIPIT PAGE
Decorated incipit pages with *Vere dignum* monogram and *Christ in Majesty*. In a sacramentary, Mainz or Fulda, ca. 1025–50. Los Angeles, JPGM, Ms. Ludwig V 2 (83.MF.77), fols. 21v–22

INCUNABLE

A printed book produced before 1501, that is, the period when the process of printing from movable type was in its infancy in Europe, from the Latin *incunabula*, meaning "swaddling clothes."

INHABITED INITIAL

An enlarged letter at the beginning of a section of a text that contains human or animal figures but not an identifiable narrative scene (which is a HISTORIATED INITIAL). Inhabited initials are particularly characteristic of ROMANESQUE illumination. BORDERS can also be inhabited.

INHABITED INITIAL
Inhabited initial *D*. In a missal known as the Stammheim Missal, Hildesheim, ca. 1170s. 28.2 × 18.9 cm (11⅛ × 7⁷⁄₁₆ in.). Los Angeles, JPGM, Ms. 64 (97.MG.21), fol. 152v (detail)

INITIAL

Strictly speaking, the first letter of a word; in practice, an enlarged and decorated letter introducing an important section of a text. Initials can have different levels of significance, according to the divisions of the text or their place within a program of decoration (see HIERARCHY). Among the most common forms of initials are ANTHROPOMORPHIC, DECORATED, GYMNASTIC, HISTORIATED, INHABITED, ZOO-ANTHROPOMORPHIC, and ZOOMORPHIC.

INK

A liquid writing and drawing medium without perceptible particles (like a dye) that is usually applied with a pen (see QUILL PEN). Ink was used for drawing and RULING as well as for writing and, when diluted, could be applied with a BRUSH. The word *ink* derives from the Latin *encaustum* ("burnt in"), since the OXIDATION of gallic and tannic acids in iron gall ink causes it to etch into the writing surface. The basis of this widely used medieval ink was a solution made from OAK GALL, iron salts (colorless ferrous sulfate, called *vitriol*), and gum Arabic (sap from the acacia tree). Pale gray when first applied, iron gall ink turns black when exposed to air and becomes dark brown as it oxidizes further. Carbon black (called *lampblack*) mixed with gum was also a common ink, often used to create RINCEAUX and the outlined features (applied with a brush) in ILLUMINATION.

INSTRUCTIONS

Directions as to the form, content, or color of what was to be written or painted in a manuscript, given by STATIONERS, SCRIBES, ILLUMINATORS, and advisers. Instructions relating to BINDING and assembly also occur. Instructions were often executed in HARD POINT, LEAD POINT, or METALPOINT to render them less intrusive.

INSTRUCTIONS

Sodom and Gomorrah. In Rudolf von Ems, *Weltchronik*, Regensburg, ca. 1400–1410. 33.5 × 23.5 cm (13³⁄₁₆ × 9¼ in.). Los Angeles, JPGM, Ms. 33 (88.MP.70), fol. 24v (detail)

The writing at the bottom edge of this page, partially trimmed away, provided the illuminator with instructions concerning the subject of the miniature.

INSULAR PERIOD

The time of close cultural interaction between Britain and Ireland, from around 550 to 900. Elements of CELTIC, GERMANIC, and Mediterranean culture fused together to form something new, entirely the product of the islands of Britain and Ireland. Insular art and learning in turn stimulated cultural development on the Continent and played a significant role in the evolution of ROMANESQUE art.

A characteristic feature of Insular book production is the integration of decoration, SCRIPT, and text. The earliest developments in Insular manuscript art seem to have occurred in sixth- and seventh-century Ireland and its outposts. Irish influence was transmitted to England and Scotland, where it fused with Germanic and Pictish artistic styles, producing a hybrid form known as Hiberno-Saxon art, represented by such famous monuments as the Lindisfarne Gospels and the Book of Kells. The influence of the art of Rome and the Mediterranean is also found in Hiberno-Saxon art.

INTERLACE

Decoration consisting of fictive straps or ribbons that appear to be interwoven. Interlace was known in ANTIQUITY and much favored in GERMANIC art, whence it was transmitted to INSULAR art, which further developed the form. It remained popular throughout the Middle Ages and RENAISSANCE.

INTERLACE
Decorated initial *D*. In a sacramentary, Beauvais, ca. 1000–1025. 23.2 × 17.9 cm (9⅛ × 7¹⁄₁₆ in.). Los Angeles, JPGM, Ms. Ludwig V 1 (83.MF.76), fol. 9

INTERNATIONAL STYLE

A term coined at the end of the nineteenth century to denote a style of late GOTHIC art practiced in the late fourteenth and early fifteenth centuries. The International Style fused diverse artistic traditions, primarily those of Paris, Holland, and Bohemia. Courtly patronage, an elegant and refined rendering of forms, and a generally sumptuous quality distinguish works in this style. Important artists include the Limbourg brothers, the MASTER of the Brussels Initials, Jacquemart de Hesdin, the Bedford Master, the Boucicaut Master, John Siferwas, Herman Scheere, Giovannino de' Grassi, and Belbello da Pavia. Among the most significant PATRONS were King Wenceslaus IV of Bohemia; King Martin of Aragon; King Charles VI of France; Jean, Duke of Berry; King Richard II of England; John, Duke of Bedford, and his wife, Anne of Burgundy; Philip the Bold, Duke of Burgundy; and Gian Galeazzo Visconti, Duke of Milan.

INTERNATIONAL STYLE
Virgil Master, *Alchandreus Presents His Work to a King*. In Alchandreus, *Liber Alchandrei philosophi*, Paris, ca. 1405. 39 × 30.5 cm (15⅜ × 12 in.). Los Angeles, JPGM, Ms. 72 (2003.25), fol. 2 (detail)

JOURNAL See DIURNAL.

KETTLE STITCH

A linking stitch at or near the HEAD and TAIL of the SPINE that connects the GATHERING being sewn to the preceding one during the process of SEWING ON SUPPORTS.

Knife

Two sorts of knife were used in producing medieval manuscripts, the *pen knife* and the *lunular knife*. The pen knife was used by SCRIBES for a number of purposes, including shaping the nib of a QUILL PEN, making CORRECTIONS by scraping out errors, PRICK-ING, and steadying the writing support—usually a BIFOLIUM of PARCHMENT—while writing. Medieval depictions of SCRIBES often show them holding a quill in one hand and a knife in the other. The lunular knife (with a curved blade) was used in making parchment. For an image of a scribe using a knife to shape a pen, see the illustration accompanying BYZANTINE.

Kyriale

The portion of a GRADUAL containing the ordinary chants (Kyrie, Gloria, Credo, Sanc-tus, and Agnus Dei) of the MASS, that is, the chants whose texts remain unchanged throughout the ecclesiastical year. In the late Middle Ages, the kyriale sometimes formed a separate volume.

Labors of the months See OCCUPATIONAL CALENDAR.

Laity

Those belonging to secular society. A lay person is neither a cleric nor a member of a religious order.

Late Antiquity

The period from the third century to the disintegration of the western Roman Empire in the fifth century or to the period of Muslim conquests of territories of the former Roman Empire in the seventh century. This period embraces some of what is generally termed the EARLY CHRISTIAN era.

Lead point

A metal STYLUS (sometimes contained in a handle) made of a lead alloy, also known as *plummet*. Used for drawing, annotation, and RULING, lead point creates a graphic mark by leaving silvery-gray deposits of the soft metal on the surface of PARCHMENT (see the illustration accompanying GLOSS). Widely used in manuscripts of the eleventh and twelfth centuries, lead point can easily be confused with graphite, a carbon-based material not generally used before the mid- to late sixteenth century. See also HARD POINT and METALPOINT.

Leaf See FOLIO.

Lectionary

A volume containing readings for use in the Christian LITURGY. See also DIVINE OFFICE, EPISTOLARY, GOSPEL LECTIONARY, and MASS.

Liber vitae

A book listing the *familiares* ("members") and benefactors of a monastic community who were to be remembered in its MASSES and in other services and prayers.

Libraire See STATIONER.

Library book

The medieval monastic library contained a wide variety of texts, including COMMENTARIES, CHRONICLES, DIGESTS, and DECRETALS, selected CLASSICAL TEXTS, MEDICAL TEXTS, HERBALS, and ASTRONOMICAL/ASTROLOGICAL TEXTS. Secular institutions, such as colleges, also had libraries. Some secular scholars—especially the HUMANISTS—had personal collections of books, as did bibliophiles, who were often aristocrats. The contents of secular libraries varied according to their owners' interests.

The markings in books associated with their storage and cataloging often provide valuable PROVENANCE information. Before the introduction of upright storage shelves in the fifteenth century, books were generally stored flat in a closet or chest known as an *armarium* or were chained to a lectern. Many library books were quite modest and inexpensive products, while others (such as biblical and liturgical volumes, chronicles, and ROMANCES) might be richly illuminated. See the illustration accompanying CHAINED BOOK.

Limp binding

A BINDING that lacks stiff BOARDS and is bound with flexible covers of PARCHMENT, PAPER, or textile. Limp bindings were generally used during the late Middle Ages and early modern period for account books and printed books as a less expensive alternative to stiff board, full-leather bindings.

Line filler

A decorative device (abstract, foliate, zoomorphic, or anthropomorphic) that fills the remainder of a line not fully occupied by SCRIPT. Line fillers often constitute an important decorative component in manuscripts of texts written in verse, including PSALTERS. For a series of line fillers, see the illustration accompanying LITANY OF SAINTS.

Litany of saints

A series of invocations for deliverance and intercession usually addressed to the Trinity, the Virgin, angels, and various categories of saints—apostles, martyrs, confessors, and virgins—individually and as groups. The saints included in a litany in a given manuscript vary according to place of origin or intended use. For this reason, they often yield valuable evidence concerning the ORIGIN of a manuscript. Litanies of saints increased in length during the course of the Middle Ages.

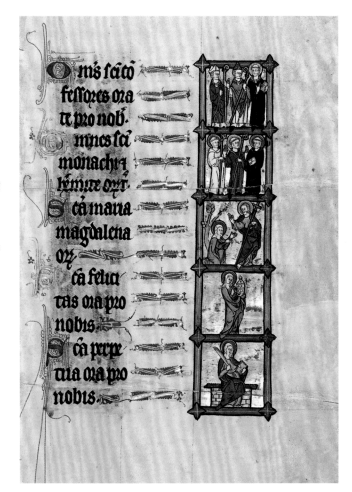

LITANY OF SAINTS

Two Bishops and a Nimbed Priest; Two Nimbed Abbots and a Nimbed Monk; Noli me tangere; Saint Felicity with an Ointment Jar; Saint Perpetua with a Book and a Martyr's Palm. In a book of hours known as the Ruskin Hours, northeastern France, ca. 1300. 26.4 × 18.3 cm (10⅜ × 7³⁄₁₆ in.). Los Angeles, JPGM, Ms. Ludwig IX 3 (83.ML.99), fol. 105

LITTERA FLORISSA (PL. LITTERAE FLORISSAE)

A PEN-FLOURISHED letter, usually composed of delicate geometric and foliate motifs. See also CADELLE, from the Latin *floridus*, meaning "flowery" or "beautiful."

LITTERA NOTABILIOR (PL. LITTERAE NOTABILIORES)

A noticeable letter within a text, often a majuscule (or uppercase) letter, designed to clarify the syntax of a passage, from the Latin *notabilis*, meaning "noteworthy" or "extraordinary." *Litterae notabiliores* most often appear at the beginning of a new sense unit of a text, and—when not at the very beginning of a text—after a mark of punctuation.

LITURGY

Rites, observances, and procedures prescribed for public worship. At the core of medieval Christian liturgy are the MASS (the celebration of the Eucharist) and the DIVINE OFFICE.

Manicula

A pointing hand symbol with extended index finger usually drawn with pen and INK in the margin of a medieval manuscript page, borrowing the Latin meaning "little hand." This sign was used to draw attention to a word or phrase and to assist the reader in locating a noteworthy passage of text. Its use continued with the advent of movable type, and it became part of the typographic repertoire of printers (called a *manicule*). See also MARGINALIA.

MANICULA
Manicula. In *Vita beatae Hedwigis*, Silesia, 1353. 34.1 × 24.8 cm (13⁷⁄₁₆ × 9¾ in.). Los Angeles, JPGM, Ms. Ludwig XI 7 (83.MN.126), fol. 37 (detail)

Mannered

A mannered style is one that appears self-conscious and somewhat artificial.

Manuscript

In its specialized meaning, a book written by hand, from the Latin meaning "hand-written." *Manuscript* is often abbreviated as *Ms.* (singular) and *Mss.* (plural).

Mappa mundi (pl. mappae mundi)

A world map. *Mappae mundi* are known to have been produced during ANTIQUITY. During the GOTHIC period, illuminated *mappae mundi* were produced for inclusion in books and as altarpieces (such as the Hereford *Mappa Mundi*). They functioned as visual encyclopedias of world knowledge, incorporating material from biblical history and texts such as the *Marvels of the East* (concerning the mythical inhabitants of the East). In the late Middle Ages, with improved accuracy in navigation and chart making, more detailed coastlines were featured. Diagrammatic world maps, such as T-O maps, which depicted the three known continents as a T contained in a circle, were also produced during the Middle Ages.

Marginalia

Writing that is in the margins of a manuscript, from the Latin meaning "things in the margin." Marginalia might be included in the original creation of a book, but they also can be of a secondary or even extraneous nature. Marginalia include GLOSSES, annotations, and diagrams. Painted decoration in the margins of manuscripts, also often referred to as *marginalia*, is usually a part of the page's decorative scheme, being attached to extensions of painted letters or incorporated in a border. For painted elements in margins, see the illustrations accompanying BAS-DE-PAGE SCENES and DROLLERY.

MARGINALIA

Text page. In Paschasius Radbertus, *De corpore et sanguine domini*, southern Europe, ca. 1120–40. 11.2 × 7.7 cm (4⁷⁄₁₆ × 3¹⁄₁₆ in.). Kalamazoo, Western Michigan University Libraries, Ms. 170, fol. 19v (detail)

In this manuscript, Chi-Rho monograms (in red with touches of yellow ocher) in the outer margin mark passages of the text thought to be particularly noteworthy. They are a part of the book's original design.

MARTYROLOGY

A book, sometimes called a *passionale*, containing a list of saints or narrative readings on the lives and martyrdoms of saints to be read in the DIVINE OFFICE at the canonical hour of prime. The contents of a martyrology are arranged according to the SANCTO-RALE of the liturgical year.

MASS

The celebration of the Christian sacrament of the Eucharist, which derived from Christ's actions at the Last Supper, and the *agape*, or love feast, of the early Church. The term stems from the dismissal at the end of the celebration, *Ite, missa est* ("the dismissal

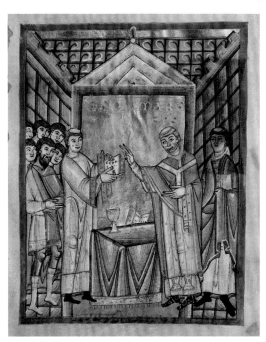

MASS
Bishop Engilmar Celebrating Mass. In a benedictional, Regensburg, ca. 1030–40. 23.2 × 16 cm (9⅛ × 6⁵⁄₁₆ in.). Los Angeles, JPGM, Ms. Ludwig VII 1 (83.MI.90), fol. 16

In this miniature, Bishop Engilmar of Parenzo is shown celebrating mass. The Eucharistic chalice is on the altar, and he makes a blessing gesture as he reads from a book held open for him by another cleric.

is here"). The texts for the celebration of the mass were first contained in the SACRAMEN-TARY and other books, and then in the MISSAL. The mass was attended daily by those in religious orders, the clergy, and, with varying frequency, members of the LAITY.

MASTER

A term frequently employed in names of convenience to identify anonymous artists, the word *master* also denotes an artist whose work is considered of importance and particularly high quality. Master ILLUMINATORS frequently attracted a following and employed others (perhaps to supply BORDERS, INITIALS, or other minor decorative components, or to assist in painting MINIATURES and other major decorative components). In some cases the name of the master is known (e.g., the Parisian illuminator Master Honoré working around 1300), but the majority of masters are anonymous and are often identified by key examples of their work or by distinctive features of their style. Among fifteenth-century artists, the Master of Guillebert de Mets is named after a SCRIBE with whom he worked on a copy of Boccaccio's *Decameron*, and the Boucicaut Master is named after the Maréchal de Boucicaut, the PATRON of one of his most important manuscripts. The Masters of the Gold Scrolls are a group of Flemish artists named for their predilection for incorporating scrollwork into their miniatures.

MEDICAL TEXTS

Texts concerning healing were frequently illustrated as an aid to their comprehension in ANTIQUITY, as evidenced by works such as the Johnson (or Wellcome) PAPYRUS of ca. 400 CE and the early HERBALS.

A number of ancient texts were preserved in the early medieval West, among them Dioscorides's *De materia medica* (in Greek), the *Herbarium* of Pseudo-Apuleius, and Placitus's *Liber medicinae ex animalibus* (*On the Medicinal Qualities of Animals*). Other classical treatises on medicine were preserved by Islamic scholars. Elements of Christian charismatic healing and of Western pagan lore were absorbed into this tradition, resulting in works such as the ANGLO-SAXON leechbooks. Beginning in the eleventh century, the natural philosophy of classical scholars such as Galen of Pergamon exerted an influence. Galen's ideas and those of Hippocrates were accompanied by the COMMENTARIES of Arabic-speaking scholars in the *Articella*, a twelfth-century text. Islamic philosophical texts containing medical data, such as those of Avicenna (eleventh century) and Averroës (twelfth century), also influenced the West during the thirteenth and fourteenth centuries. Practical treatises were composed in the high and late Middle Ages, including Roger Frugardi's *Chirurgiae* (ca. 1180) and John Arderne's *Practica* (1376), along with manuals on health such as that by Aldobrandino da Siena of the thirteenth century.

Many of the illustrations accompanying medical works are diagrammatic, including depictions of the Zodiac Man, the Bloodletting Man, the Muscle Man, the Wound Man, and the Disease Woman, whose bodies are labeled with appropriate afflictions or symbols. The Zodiac Man, for example, shows the propitious time for treating various ailments in any part of the body.

Luxuriously illuminated medical manuscripts were produced in the late Middle Ages, stimulated by the increase in secular patronage. Monastic libraries contained a

MEDICAL TEXTS
The Zodiac Man. In
a medical miscellany,
Germany, fifteenth
century. 21 × 15 cm
(8⁵⁄₁₆ × 5¹⁵⁄₁₆ in.).
London, The British
Library, Ms. Arundel
251, fol. 46

number of medical manuscripts, and universities, notably those of Paris and Salerno, also contributed to the dissemination of these texts.

MEMBRA DISJECTA

Detached leaves from a MANUSCRIPT, from the Latin *membrum disjectum*, meaning "scattered piece."

MEMORIAL See SUFFRAGE.

METAL FURNISHINGS

Metal pieces added to a wooden BOARD BINDING. See also BOSS, CENTERPIECE, CHAINED BOOK, CLASP AND CATCH, and CORNERPIECE.

METALPOINT

A writing and drawing implement, made of soft metal alloy used to make a graphic mark, typically in manuscripts for RULING, UNDERDRAWING, and annotation. The mark on the surface varies in appearance according to the metal used (and any alloys present), with silver point and LEAD POINT being the most commonly used in the medieval period. The marks produced are more discreet than those made with INK but more visible than those made with a HARD POINT.

MICROSCOPY
Photomicrograph from
Pacino di Buonaguida,
The Ascension of Christ.
Leaf from the Laudario of
Sant'Agnese, Florence, ca.
1340. 44.4 × 31.8 cm (17½
× 12½ in.). Los Angeles,
JPGM, Ms. 80a (2005.26),
verso

Under a stereomicroscope, the light blue base pigment layer can be seen in this photomicrograph to consist of a white pigment mixed with bright mineral blue particles and modeled with strokes of a transparent pink colorant layered on top. Also evident are cracks throughout the paint layers.

MICROSCOPY

The use of a microscope for the examination of materials, either in situ (with a boom stereomicroscope) or on removed samples (typically mounted on a microscope slide). Use of a boom stereomicroscope in the study of manuscripts enhances the close visual study of their material components. For instance, hair follicles of PARCHMENT or the qualities of the fibers in PAPER can often be perceived. Layering of INKS and paints can be readily observed in order to determine the sequence of their application and to identify later interventions in illuminations. The observation of PIGMENT particles can help ascertain whether some paints consist of pigment mixtures. Microscopic analysis can also determine the extent of physical deterioration in pigments and inks, such as cracking, flaking, and loss. When the microscope is equipped with a camera, images captured during microscopy (called *photomicrographs*) additionally provide documentation of these visible features.

MINIATURE

An independent illustration in a manuscript, as opposed to a scene incorporated into another element of the decorative scheme such as a BORDER or INITIAL. It takes its name from the Latin *miniare*, meaning "to color with red" (the adornment of books originally was executed largely in a red PIGMENT derived from lead, called *minium*).

MISE-EN-PAGE

The layout of a page, borrowed from the French meaning "placement on the page." Significant developments in the *mise-en-page* of manuscripts include the standardization of a one- or two-column layout during LATE ANTIQUITY and the EARLY CHRISTIAN period (initially four columns might be used, in emulation of an unrolled section of a ROLL). Experiments with complex layout and RULING patterns to accommodate GLOSSES, COMMENTARIES, and other parallel texts took place during the CAROLINGIAN period and later within university book production. Another important development was the standard adoption of a layout wherein the top line of text was written "below top-line" rather than "above top-line" of the ruling. This change appeared in the first half of the thirteenth century and serves as a useful criterion for dating manuscripts. For an example of a complex *mise-en-page*, see the illustration accompanying GLOSS.

Missal

A Christian SERVICE BOOK containing the texts necessary for the celebration of the MASS (including chants, prayers, and readings), together with ceremonial directions. The prayers and other texts recited by the priest were originally contained in the SACRAMENTARY, which was used together with the GRADUAL, the GOSPEL LECTIONARY, and the EPISTOLARY for the celebration of high or solemn mass. The missal was developed from the sacramentary in the tenth and eleventh centuries and came to replace it by the thirteenth century. Its popularity was assured by the custom of saying low masses, which were performed by the celebrant alone. Principal fields for decoration in the missal are the CANON PAGE and the *Vere dignum* monogram. For a *Vere dignum* monogram, see the illustration accompanying INCIPIT PAGE.

Missal
Master of the Brussels Initials, *The Ascension; initial V: Two Apostles.* In a missal, Bologna, ca. 1389–1404. 33 × 24 cm (13 × 9⁷⁄₁₆ in.). Los Angeles, JPGM, Ms. 34 (88.MG.71), fol. 146v

Model

An image on which a copy is based. The model for a text is called an EXEMPLAR.

Model book

A book in which an artist recorded designs, often accompanied by notes relating to color and composition. Many model books must have existed, but very few have survived. Some late BYZANTINE examples are extant. A famous Western example is that produced by the artist Villard de Honnecourt in the thirteenth century. The early

fifteenth-century sketchbook of Jacques Daliwe, executed on boxwood tablets, is a rare example of the sort of sketches that must have existed in quantity in the late Middle Ages. FLYLEAVES sometimes carry designs of the type found in model books. Waste materials such as fragments of wood, slate, or bone were often used to try out designs; these are known as *motif pieces.*

MODELING

The painting technique that gives objects the appearance of three-dimensionality through the addition of shading in darker hues and highlighting areas with light value colors or painted gold, or by using contrasting colors (see COULEUR CHANGEANTE).

MONASTIC PRODUCTION

From the EARLY CHRISTIAN period until the rise of the universities around 1200, book production was largely centered in monastic SCRIPTORIA, with male and female religious participating in the work. A scriptorium could operate under a supervisor, and the work teams varied in composition, from a single artist-SCRIBE who was responsible for a whole book to extensive teams of scribes, RUBRICATORS, ILLUMINATORS, correctors, and BINDERS. The sequence of work also varied, but the general procedure seems to have entailed the writing of the main text, its CORRECTION, rubrication, and ILLUMINATION, followed by sewing and BINDING. Work in the scriptorium represented one part of the daily work in a monastic community, as prescribed by its rule. Monastic production continued alongside SECULAR PRODUCTION during the high and late Middle Ages.

MOTTO

A word or phrase attached to an EMBLEM, often explaining or emphasizing its symbolic value. In HERALDRY a motto is a word or phrase carried on a scroll and placed below an achievement of arms or above a crest. The motto can refer to the name or exploits of the bearer or to elements included in the arms, or can simply be a pious expression.

MOTTO

Jean Fouquet, *Coat of Arms Held by a Woman and a Greyhound.* In a book of hours known as the Hours of Simon de Varie, Tours and possibly Paris, 1455. 11.4 × 8.3 cm (4½ × 3¼ in.). Los Angeles, JPGM, Ms. 7 (85. ML.27), fol. 2v

The mottoes of Simon de Varie, patron of the manuscript, are included on this page: *Vie à mon desir* ("Life according to one's desire") and *Plus que jamais* ("More than ever").

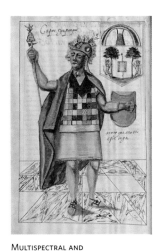

scan 01 (420 nm)

scan 10 (600 nm)

scan 20 (800 nm)

scan 30 (1000 nm)

MULTISPECTRAL AND
HYPERSPECTRAL IMAGING
Capac Yupanqui. In Martín de
Murúa, *Historia general del Piru*, La
Plata, Bolivia, completed in 1616.
28.9 × 20 cm (11⅜ × 7⅞ in.). Los
Angeles, JPGM, Ms. Ludwig XIII 16
(83.MP.159), fol. 30v

Four selected images from a 30-band multispectral image are shown here,
illustrating the different reflectance response of inks and pigments at different
wavelengths. Shorter wavelengths (e.g., 420 nm) may highlight regions with
similar organic components (e.g., binders), whereas longer wavelengths begin
to penetrate through the pigments and may highlight different features (cf.
800 and 1000 nm). Examination of the complete set of images taken from
the ultraviolet through the infrared helps the researcher identify correlations
between materials across the area under investigation.

MULTISPECTRAL AND HYPERSPECTRAL IMAGING

Forms of multimodal imaging. Historically, the most commonly employed imaging techniques used outside the visible range are infrared (IR) imaging, which can help reveal carbon-based UNDERDRAWING beneath a paint layer, and ultraviolet (UV) reflectance imaging, which can visually enhance materials on the surface of an ILLUMINATION, such as partially erased iron gall INK inscriptions or PIGMENTS used in later retouching or OVERPAINTING. Multispectral and hyperspectral imaging are specialized forms of such imaging in which a series of reflectance images are collected, each at a different wavelength (or wavelength region) of light. When a small number of images are collected (<100), the technique is typically termed *multispectral imaging*; when a large number (>100) are collected, the term *hyperspectral imaging* is often used. Because images are collected over a wide range of wavelengths, this type of imaging can capture subtle differences between materials that appear to be similar in traditional IR or UV imaging. Additionally, multispectral and hyperspectral imaging data can be used to generate reflectance spectra that can facilitate pigment identification. See also REFLECTANCE SPECTROSCOPY.

MUSIC MANUSCRIPTS

Manuscripts with texts to be sung. Some were illuminated, and the extent of ILLUMINATION depended largely on patronage and purpose. Depictions of musicians and instruments frequently appear in medieval manuscripts as DROLLERIES and in INITIALS and BAS-DE-PAGE SCENES.

Music was incorporated into the Christian LITURGY early on, and the study of music theory was part of the ancient and medieval liberal arts syllabus. Unaccompanied

unison singing, called *plainchant*, was the traditional music of the Western Church. By the eleventh century, *vocal polyphony*—music with two or more melodically independent parts—was being practiced at Winchester in England. A particularly rich repertoire of polyphony came from the cathedral of Notre Dame in Paris. Polyphony made certain chants of the MASS longer and more complex.

There is little early written evidence for secular music, although there was probably a rich oral tradition, but collections of the songs of troubadours and trouvères, usually without music notation, survive from the mid-thirteenth century on, by which time the courtly poet-composer had achieved professional status.

The notation of Christian liturgical music initially appears in the form of *neumes*—graphic symbols written above the text and indicating the rise and fall of the melody or repetitions of the same pitch—on an open field (without lines) and usually without indicating precise pitches. Twelve to fifteen regional families of these early neumes have been identified. Neumes came to be written on a four-line staff in the high Middle Ages, at which time Eastern European music manuscripts adopted Gothic (or Hufnagel) notation, with the points and curves of earlier neumes being replaced by lozenge-shaped noteheads and generally more angular forms. A similar development in the Île de France gave rise to the use of *square notation*, named for the shape of the noteheads, in the late twelfth century. For an example of Gothic notation, see the illustration accompanying ANTIPHONAL, and for square notation the illustration accompanying DECORATED INITIAL.

NATURALISTIC PAINTING

A depiction that seeks to represent the appearance of things, without artificiality or stylization.

NOCTURNAL See DIURNAL.

OAK GALL

An abnormal growth that forms on oak trees. Oak galls contain high concentrations of gallic and gallotannic acids, which form the basis of iron gall INK. Oak gall (like oak bark) can also be used in TANNING.

OBIT

A note recording a death. Obits were often entered into CALENDARS to commemorate the deceased and can provide valuable PROVENANCE information.

OCCUPATIONAL CALENDAR

A CALENDAR incorporating a series of illustrations that depict the labors appropriate to each of the months (e.g., the labor for June is reaping, that for August, mowing). Images of the labors of the months began to appear in calendar decoration, along with zodiacal signs, in LATE ANTIQUITY and became increasingly popular during the high and late Middle Ages. The scenes were usually agrarian in character, but some fifteenth-century manuscripts (notably the Très Riches Heures of Jean de Berry and the Sforza Hours) juxtaposed these with scenes from courtly life.

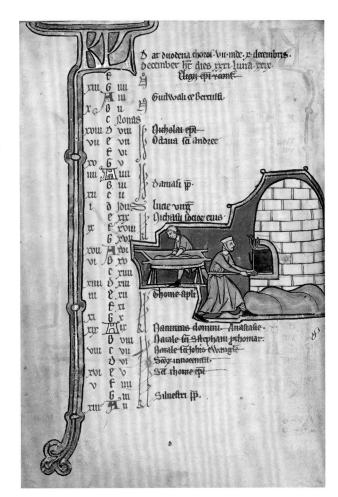

OCCUPATIONAL CALENDAR
Baking Bread. In a psalter, Belgium, possibly Bruges, ca. mid-thirteenth century. 23.5 × 16.5 cm (9¼ × 6½ in.). Los Angeles, JPGM, Ms. 14 (85.MK.239), fol. 8v

On this page, the activity of baking bread is depicted as the labor for the month for December.

OCTATEUCH

The first eight books of the Christian Old Testament, which were sometimes, especially in the BYZANTINE East, contained in a single, separate volume.

OCTAVO

The size designation of a volume measuring one-eighth the size of a full sheet of writing material.

OFFICE See DIVINE OFFICE.

ORDINAL

A guide to the celebration of the Christian LITURGY, including INCIPITS of the texts to be spoken or sung and instructions for liturgical actions to be carried out by the clergy.

Origin

The place of origin of a manuscript is seldom recorded (unless mentioned in a COLO-PHON) and has to be assessed by a study of the book's contents, patronage, method of production, and PROVENANCE. The USE of a liturgical manuscript is not necessarily an indicator of its place of origin, since the major uses enjoyed a wide geographic currency.

Orthography

The art of writing words correctly, from the Greek *orthographia*, meaning "correct writing." The term has come also to be used more narrowly to mean *spelling*. Orthographical variants may assist in localizing a manuscript; INSULAR scribes, for example, interchanged *ss* and *s*. Orthographical practices can also help in the identification of individual SCRIBES.

Ottonian

Of or pertaining to the Saxon Liudolfing, or Ottonian, dynasty that ruled the East Frankish portion of the CAROLINGIAN Empire from 919 to 1024. The dynasty's extensive art patronage, along with that of contemporary clerics, encouraged the arts. In the visual arts, including manuscript ILLUMINATION, there was a noticeable continuity with Carolingian art, coupled with influences from Italy and the BYZANTINE Empire. The marriage of Otto II (955–983) to a Byzantine princess, Theophano, who later acted as regent for her son Otto III (980–1002), played a significant role in transmitting Byzantine influences to the West. Many of the books of this period are sumptuously illuminated liturgical volumes, featuring an opulent use of gold and text areas painted purple in imitation of the PURPLE PAGES of LATE ANTIQUE manuscripts. The largely itinerant Ottonian court was instrumental in stimulating the production of MANU-SCRIPTS (principally those of the so-called Liuthar Group), with monastic SCRIPTO-RIA, including those at Reichenau, Regensburg, and Echternach, producing important illuminated books. See the illustration accompanying INCIPIT PAGE.

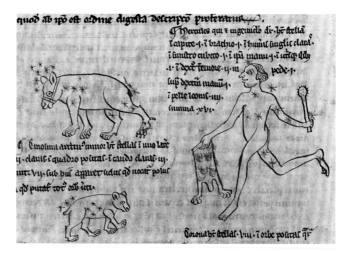

OUTLINE DRAWING
Constellation diagrams. In *Miscellany of Texts on the Quadrivium*, England, ca. early thirteenth century. 24.1 × 15.6 cm (9½ × 6⅛ in.). Los Angeles, JPGM, Ms. Ludwig XII 5 (83.MO.134), fol. 149v (detail)

Outline drawing

A style of ILLUMINATION in which only the outlines of the figure or object are drawn, in black or colored INK. There appears to have been a classical tradition of outline drawing that was adopted and developed in INSULAR, ANGLO-SAXON, and CAROLINGIAN art. In an illumination, the technique could be used exclusively or in conjunction with FULLY PAINTED elements. Outline drawing was also frequently employed in the rendering of diagrams. Compare TINTED DRAWING.

Overpainting

Painting executed over an existing paint layer or the retouching of a design to restore areas of loss or abrasion. Overpainting was sometimes done to coats of arms when a manuscript changed owners (for an example, see the illustration accompanying MOTTO).

Oxidation

A chemical change that results in the loss of electrons (typically due to the loss of hydrogen or gain of oxygen-species or halogens). Such chemical reactions are often observed on materials found in manuscript ILLUMINATION. Oxidation reactions, which in some cases can result in physical deterioration, may be exacerbated by poor storage conditions, exposure to moisture, or atmospheric pollution. One well-known

OXIDATION

Text page. In *Roman de Gillion de Trazegnies*, Antwerp, after 1464. 37 × 25.5 cm (14⁹⁄₁₆ × 10¹⁄₁₆ in.). Los Angeles, JPGM, Ms. 111 (2013.46), fol. 228 (detail)

On this page, the oxidation of iron gall ink has caused perforations through the parchment.

OXIDATION

Painted border. In a psalter, London, ca. 1420–30. 35.6 × 24.1 cm (14 × 9½ in.). Los Angeles, JPGM, Ms. 17 (85.MK.318), fol. 1 (detail)

Exposure to sulfur in air pollution (possibly from coal smoke in earlier centuries) has affected the painted border design on this page, causing the lead white pigment of the flower petals to darken to gray.

example of oxidation is the deterioration of iron gall INK. Oxidation reactions involving sulfur (either from exposure to sulfur dioxide in air pollution or from contact with sulfur-containing materials) can also cause chemical alterations, such as the tarnishing of metallic silver and the darkening of lead-based PIGMENTS. Exposure of manuscript illumination to unfiltered light can cause photo-oxidation, which typically induces color change (e.g., fading) in light-sensitive organic colorants and can also impact the stability of substrates such as PARCHMENT.

PALEOGRAPHY

The study of the history of SCRIPTS, their adjuncts (such as ABBREVIATION, ORTHOGRAPHY, and punctuation), and their decipherment, from the Greek *palaiographia*, meaning "old writing." The fifteenth-century HUMANISTS were the first to attempt to distinguish styles of handwriting according to date, but the discipline really began to develop during the seventeenth century. At this time, Jean Bolland (1596–1665), leader of a group of Flemish Jesuits, was a key figure in producing an authoritative compendium of SAINTS' LIVES. In the process, the Bollandists established criteria for determining the authenticity of documents through the analysis of script. Jean Mabillon, a Benedictine monk of Saint-Germain-des-Prés, then published *De re diplomatica* (1681), which includes a section on the history of handwriting and uses paleography to argue for the validity of certain ancient grants to the Benedictine order. Mabillon's principles for assessing the authenticity of documents gave rise to the formal discipline of paleography. Subsequent landmarks in the discipline include the *Nouveau traité de diplomatique* (1750–65) by the Benedictines René-Prosper Tassin and Charles-François Toustain, Charles-François-Bernard de Montfaucon's *Palaeographia graeca* (1708), and the work of Francesco Scipione Maffei (1675–1755). In the twentieth century, schools of paleography were defined by the approaches of key scholars, such as Ludwig Traube (1861–1907) and E. A. Lowe (1879–1969).

PALETTE

The range of colors used in a work. The term derives from the name of the flat surface on which paints are sometimes mixed, although shells were more commonly used to contain prepared PIGMENTS during the Middle Ages.

PALIMPSEST

A MANUSCRIPT (or separated leaves) from which the original writing has been erased in order to reuse the support for the writing of a different text, from the Greek *palimpsestos*, meaning "scraped again." The term also applies to the original text of such a document. Given the value of writing support materials in ANTIQUITY and the medieval period, text INK would be erased (by washing in the case of PAPYRUS and by using PUMICE or other scraping methods in the case of PARCHMENT) so that the support could be reused and overwritten. Since erasure was not always complete, traces of the underlying text can sometimes be read with the assistance of ultraviolet light or MULTISPECTRAL AND HYPERSPECTRAL IMAGING, or by mapping the chemical

elements in the ink (such as iron) by x-ray fluorescence (XRF) spectroscopy scanning.

PANEL-STAMPED BINDING

A binding decorated by means of a large engraved or cast metal block that is impressed into the covering leather. A single panel stamp could decorate a large part or the whole of a book's cover (for an example, see the illustration accompanying TOOLING). Far more efficient than tooling with individual hand tools, panel stamping was introduced as early as the thirteenth century in Flanders, and the embellishment method continued to be used by BINDERS across Europe until the mid-sixteenth century.

PAPER

A writing support material traditionally made by hand from macerated plant (cellulose) fiber suspended in a water bath, deposited on a screen, drained, transferred, pressed, and dried. Plant fiber in medieval European papermaking was obtained largely from recycled cotton and linen rags, that were soaked and pulverized until reduced to a pulp. Paper is made on a paper mold, a wooden frame strung with wires to form a woven mesh screen and a secondary wooden frame called a *deckle*: these components were held together by the papermaker and dipped into a pulp slurry and agitated until the fibers were evenly deposited in a thin layer across the surface of the screen. The deckle was then removed, and the evenly deposited fibers, now formed into a thin sheet, were transferred (*couched*) in a single, quick motion of turning over the mold and placing the wet sheet onto a stack. Paper molds often incorporate a wire relief design (often pictorial or a monogram) that creates a translucent image in the paper known as a WATERMARK. To make a sheet suitable for writing, an adhesive size was added, either to the vat of pulp prior to sheet formation or brush-applied to the dried sheet.

Papermaking has its origins in China in the second century BCE and traveled with the spread of Buddhism to China's westernmost regions. With the Muslim unification of lands across central Asia in the eighth century, Arab adoption of papermaking developed over the course of the ninth and tenth centuries and spread west to Syria-Palestine and across the Mediterranean to Byzantium, Egypt, North Africa, and Spain. Islamic papermakers, like their central Asian predecessors, used rags as the predominant source for fiber, sized their paper with starch, and burnished the surface. Early European papermaking methods stemmed from this tradition. European papers were made from rags and sized with gelatin.

The oldest Greek manuscripts made of paper (*carta* or *charter*) were produced during the ninth century, although paper was not used regularly for BYZANTINE manuscripts until the late twelfth century and after. Paper was made in Muslim Spain beginning in the mid-eleventh century, and by the mid-thirteenth century the first paper mills were established in Italy. During the twelfth and thirteenth centuries, paper was used in Italy and the Mediterranean for ephemeral documents such as

merchants' notes and notarial registers. Not until the late fourteenth century did production begin to spread north of the Alps to Switzerland, the Rhineland, France, and England. With the rise of printing in Europe in the second half of the fifteenth century, paper mills were firmly established across the European Continent.

Papyrus

A writing support material made from the papyrus plant, a species of sedge that grew abundantly in ancient Egypt, where it was used from about 3000 BCE. The outer rind of the stem of the papyrus plant was peeled off and the rest cut or peeled into strips that were laid side by side vertically, with another layer of strips then overlaid horizontally. The whole was dampened and beaten. The overlapping strips fused during this process, forming a sheet that was then trimmed and smoothed with PUMICE. The next step was to attach the sheets with paste to form a ROLL. Papyrus was also used for single-sheet documents and folded to form CODICES. The side with the fibers running horizontally was generally used for writing with a reed pen: the horizontal fibers guided the writing on the inner surface.

Papyrus was sturdy and plentiful, and apparently it was rarely reused. There is some indication that trade embargoes during ANTIQUITY led to experiments with other materials, such as PARCHMENT, which generally replaced papyrus as the writing support for literary texts by the fourth century CE. Papyrus continued to be used, however, for documents produced in the chanceries of Merovingian Gaul and Ravenna during the sixth and seventh centuries, and the papal chancery used it until the eleventh century.

Parchment

A writing support material made from the skins of animals that have been soaked, dehaired, scraped, and dried under tension. The word *parchment* (from the Latin *pergamenum*) is derived from the ancient city of Pergamon in western Anatolia, said to be an early production center. The term is often used generically to denote animal skin prepared to receive writing regardless of species. Typically made from calf, sheep, and goat skins, parchment is necessarily made from the skins of very young animals to achieve the thin, flexible, pale-colored writing support desired by SCRIBES. The term *vellum* is sometimes reserved for calf skin and is used by modern book dealers and PARCHMENTERS to denote the finest quality skins.

Once an animal skin was defleshed in a caustic bath of slaked lime (calcium hydroxide in water), it was rinsed, stretched on a frame, and scraped while damp and under tension with a lunular KNIFE (i.e., a knife with a curved blade). The skin could be whitened with a substance such as CHALK, which aided in the removal of any remaining flesh, and sanded with PUMICE. For calfskin, both hair and flesh sides were scraped once the skin had dried under tension (a process called *shaving*) to create well-matched surfaces and an even appearance on both sides (see also FLESH SIDE and HAIR SIDE). Differences in preparation technique affected the surface appearance of the parchment, as did the type of skin used.

Parchment supplanted PAPYRUS across the Mediterranean in the early centuries CE, as it could be folded readily into GATHERINGS and sewn into CODEX form. In Europe,

with the rise of printing, parchment was eventually replaced by PAPER in the sixteenth century, although it remained in use for certain high-quality books (both manuscript and print), as well as for important legal and honorific documents. A glue made from the shavings and small pieces of parchment, when soaked, heated, and reduced to a liquid, is called *parchment size*.

PARCHMENTER

A person responsible for making PARCHMENT. Parchmenters generally obtained hides from butchers and tanners, while some monastic institutions, including certain Cistercian houses in England, produced parchment from animals raised on their own lands. Commercial parchmenters often formed trade groups (*guilds*), with workshops located near a town's water supply, a resource necessary for parchment production. The parchmenter prepared the skins, while on the frame, as thoroughly as possible for writing. Once the parchment sheet was cut from the frame, the final finishing treatment might be done by a STATIONER or a SCRIBE.

PARCHMENTER
Parchment repair. In a New Testament with the canons of Priscillian, France, probably Pontigny, ca. 1170. 43.5 × 31.4 cm (17⅛ × 12⅜ in.). Los Angeles, JPGM, Ms. Ludwig I 4 (83.MA.53), fol. 117v (detail)

A series of small parallel cuts into the surface of the parchment made by the glancing blows of the scraping knife caused a split in the parchment that was carefully stitched by the parchmenter while the skin was stretched on the frame. This repair was judiciously avoided by the scribe when writing.

PASSIONALE See MARTYROLOGY.

PASTEDOWN

A leaf pasted onto the inside of a BOARD to conceal the CHANNELING and PEGGING and the TURN-INS of the BINDING. A pastedown that is conjoint with a FLYLEAF (or text page from the first or last GATHERING) performs a mechanical function by strengthening the board attachment. Pastedowns in high and late medieval bindings were sometimes formed of fragments of earlier manuscripts that were considered dispensable.

PATRISTIC TEXTS

Texts written by the Church Fathers, whose authority was particularly respected in later periods. Well-known patristic authors include Saint Augustine, Saint Jerome, and Saint John Chrysostom.

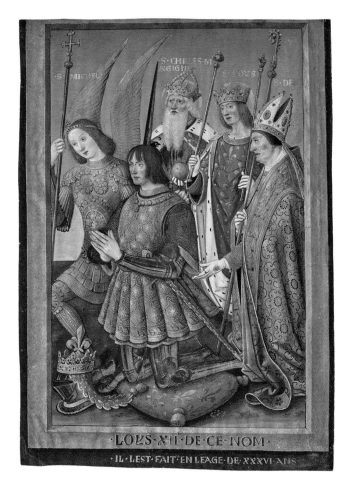

PATRON

Jean Bourdichon, *Louis XII of France Kneeling in Prayer, Accompanied by Saints Michael, Charlemagne, Louis, and Denis.* Detached leaf from a book of hours known as the Hours of Louis XII, Tours, 1498/99. 24.3 × 15.7 cm (9⁹⁄₁₆ × 6³⁄₁₆ in.). Los Angeles, JPGM, Ms. 79a (2004.1), recto

PATRON

The person responsible for commissioning a work. Portraits of patrons in MANUSCRIPTS are known throughout the Middle Ages and RENAISSANCE, but they grew in popularity beginning in the fourteenth century.

PECIA SYSTEM

A system used from the thirteenth century on, in which university-approved EXEMPLARS of texts were divided into sections and were hired out by STATIONERS to SCRIBES for copying, borrowing the late Latin *pecia*, meaning "piece." Not all books, even those for school use, were subject to the pecia system. The sections often carried an abbreviation of the word *pecia* (for example, *pᵃ*) and a numeral, written inconspicuously in the margin.

PEGGING

The securing of the end slips of the sewing supports (typically CORDS or THONGS) to the BOARDS of a BINDING by means of dowels or pegs, generally of wood. By anchoring the supports in this way, the attachment of the covers is ensured. See SEWING ON SUPPORTS.

Pen See QUILL PEN.

PEN-FLOURISHED INITIAL

An INITIAL letter with fine linear embellishment, produced with a thin pen, usually in colored inks. Blue and red were generally used during the late ROMANESQUE and GOTHIC periods. Green, common in Anglo-Norman manuscripts, was rarely used after 1200. Violet is found in manuscripts of the final quarter of the thirteenth century virtually everywhere except Paris, and purple occurs during the fourteenth and fifteenth centuries. Pen flourishing can also be applied to other decorative components.

PEN-FLOURISHED INITIAL
Decorated initial *D*. In a book of hours known as the Ruskin Hours, northeastern France, ca. 1300. 26.4 × 18.3 cm (10⅜ × 7³⁄₁₆ in.). Los Angeles, JPGM, Ms. Ludwig IX 3 (83.ML.99), fol. 109

PENTATEUCH

The first five books of the Hebrew Bible and the Christian Old Testament, which were sometimes incorporated into a single CODEX. In a medieval Jewish context, the text was in Hebrew. The Rothschild Pentateuch in the collection of the J. Paul Getty Museum is a famous illuminated example dating from the late thirteenth century.

PEN TRIAL

A test of a newly trimmed pen nib often found on FLYLEAVES, termed *probatio pennae* in Latin.

PENWORK INITIAL

An ornamental INITIAL produced entirely with a pen.

PERICOPE BOOK See GOSPEL LECTIONARY.

Picture cycle

A series of illustrations of related subject matter. One of the most prevalent types of picture cycle in illuminated manuscripts is the PREFATORY CYCLE, which precedes a book's main text. The presence of a prefatory cycle of scenes from the BIBLE is a characteristic feature of PSALTERS. Some illustrative cycles mark the major divisions of a text, such as the scenes from the life of the Virgin in a BOOK OF HOURS or scenes heading the chapters of a ROMANCE or CHRONICLE. Illustrations of the individual subjects of texts, such as those in a BESTIARY or HERBAL, also form a picture cycle.

Pigment

A colored substance (ground into a fine powder) used to make an opaque paint. The pigments used in manuscript ILLUMINATION derive from minerals (such as colored earth and semiprecious stones), organic matter (vegetable and insect extracts), and inorganic materials (chemically synthesized from metals and metallic ores). These materials are pulverized and ground to a fine powder and mixed with a BINDING MEDIUM.

Colorants from plant materials, harvested in season, or insect bodies were soaked, crushed, and cooked to make translucent colorants. These could be used immediately as a dye on textile or mixed with a binding medium to be used as an INK or paint. Organic colorants could be preserved as CLOTHLET colors or precipitated with a *mordant* (an inorganic salt) to create a lake pigment, a method used to transform a colored dye into a solid material that could be ground into a powder and mixed with a binding medium to create a paint.

Chemically synthesized pigments (described as being made by alchemy) were manufactured by crushing naturally occurring mineral ores (such as cinnabar and sulfur) and heating them to create a reaction product, such as vermilion red. Metals (such as copper or lead) exposed to chemical reagents (such as wine, vinegar, or urine) create metallic salts. Copper green and lead white are opaque pigments created by chemical reactions with these metals.

During the early Middle Ages, SCRIBES and ILLUMINATORS ground and prepared their own pigments, perhaps with the aid of an assistant. With the growth of more specialized, commercial production in the thirteenth century, illuminators often purchased their ingredients in prepared form from a STATIONER or an apothecary. With the expansion of international trade and the rise of experimental science in the fourteenth century, many colors were added to the traditional PALETTE, including organic colorants from the Far East, such as indigo blue, saffron yellow, and brazilwood red imported from India and Southeast Asia. These colorants significantly affected the coloristic range and style of illumination.

It is a common misconception that pigments were used by illuminators only in their pure form. Technical analysis reveals that pigments were frequently mixed by illuminators working in the high and late Middle Ages (see MICROSCOPY). Pigments can be difficult to identify conclusively without scientific methods of analysis, such as RAMAN SPECTROSCOPY, X-RAY FLUORESCENCE (XRF) SPECTROSCOPY, and other noninvasive techniques (see also REFLECTANCE SPECTROSCOPY and MULTISPECTRAL AND HYPER-SPECTRAL IMAGING). The stability of pigments used in manuscript illumination varies

considerably, depending upon their preparation method and exposure over time to deleterious environmental conditions, such as extreme heat, high humidity, water, air pollution, and ultraviolet radiation (see OXIDATION).

PLUMMET See LEAD POINT.

PONTIFICAL

A Christian SERVICE BOOK that reached its mature form in the tenth century, containing the order of service for those sacraments administered exclusively by a bishop, such as the consecration of churches and altars and the ordination of clergy.

POUNCE

A substance such as CHALK, ash, powdered bone, bread crumbs, or PUMICE that is crushed into a powder and rubbed into a writing surface to improve it. Pounce can reduce greasiness, raise the nap, and whiten the surfaces of PARCHMENT. The term is also used for a technique employed most often in wall and panel painting for the transfer of an image by applying a colored powder (such as black chalk) through a pricked template.

PRAYER BOOK

A Christian devotional book whose core text comprises prayers. Collections of prayers for private devotional use appeared as early as the eighth century in the INSULAR world and shortly thereafter in the CAROLINGIAN Empire. In ninth-century England, prayers were collected according to central devotional themes and were often accompanied by passages from the Gospels and the Psalms. Within the Carolingian and OTTONIAN milieus, series of prayers were often included in PSALTERS, but without a thematic structure. Throughout the Middle Ages, prayer books supplemented the psalter and the BOOK OF HOURS as volumes intended for devotional use. Prayer books grew in popularity during the late Middle Ages, and a number containing fine ILLUMINATIONS were produced for aristocratic PATRONS (such as Charles the Bold, Duke of Burgundy) in the fifteenth century. See the illustration accompanying CADELLE.

PRE-CAROLINGIAN CULTURES

The cultures in much of mainland Europe prior to the establishment of the CAROLINGIAN Empire. During the pre-Carolingian period, GERMANIC peoples (such as the Franks, Visigoths, Ostrogoths, Lombards, and Burgundians) established a number of kingdoms in what had been the western Roman Empire. Their cultures represented a fusion of pagan Germanic and Christian, including Arian, traditions. Certain monasteries (including those at St. Gall, Bobbio, Luxeuil, and Corbie) preserved elements of the learning and culture of LATE ANTIQUITY. The pre-Carolingian period saw the increasing application of ornament to text and the development of the decorated letter.

The term *pre-Carolingian* is used in a more specific context when referring to the culture of Gaul from the fifth to the eighth century—that is, Merovingian Gaul before the Carolingian period.

PREFATORY CYCLE

A series of full-page MINIATURES that introduces a text. The prefatory cycle in manuscript PSALTERS reached a developed form in ANGLO-SAXON England in the mid-eleventh century (in the Tiberius Psalter). Prefatory cycles in psalters usually consist of scenes from the BIBLE. See the illustration accompanying GOTHIC.

PRESENTATION MINIATURE

A MINIATURE depicting the presentation of a book to its PATRON or DONOR. Strictly speaking, the presentation miniature appears only in the presentation copy of a text, but such images frequently entered into the decorative program and were included in subsequent copies (in which case the term *dedication miniature* is preferable). Although encountered earlier, presentation miniatures became popular with the increased patronage of new texts and translations by secular rulers during the fifteenth century.

PRESENTATION MINIATURE
Master of the *Jardin de vertueuse consolation, Vasco da Lucena Giving His Work to Charles the Bold*. In Quintus Curtius Rufus, *Livre des fais d'Alexandre le grant*, Bruges, ca. 1470–75. 43.2 × 33 cm (17 × 13 in.). Los Angeles, JPGM, Ms. Ludwig XV 8 (83.MR.178), fol. 2v (detail)

PRICKING
Initial *E: A Female Figure.*
In a psalter, Würzburg,
ca. 1240–50. 22.7 ×
15.7 cm (8¹⁵/₁₆ × 6³/₁₆ in.).
Los Angeles, JPGM, Ms.
Ludwig VIII 2 (83.MK.93),
fol. 93

PRICKING

The marking of a FOLIO or BIFOLIUM by a point or KNIFE to guide RULING. The term also refers to the series of marks that resulted. Pricking could be done before or after the bifolia were folded to form a GATHERING.

PRIMER

Alternative name for a BOOK OF HOURS.

PROBATIO PENNAE (PL. PROBATIONES PENNAE) See PEN TRIAL.

PROGRAM See PICTURE CYCLE.

PROTEOMICS

The analysis of a complete protein profile. Proteomics is being applied to the study of cultural heritage materials, including PARCHMENT, animal glues, and other protein-containing materials using minimally invasive sampling methods. For parchment, proteomics can verify the species of animal from which a sample comes.

PROVENANCE

The history of an object's ownership. Provenance information for manuscripts may be deduced from evidence relating to the original commission or subsequent ownership of a volume (such as HERALDRY, EMBLEMATA, DEVICES, MOTTOES, OBITS, EX LIBRIS INSCRIPTIONS, bookplates, and library labeling) or from references in catalogs, correspondence, and other records.

Psalter

The biblical book of Psalms and a type of Christian devotional book that has the Psalms as its core text. Ancillary texts found in medieval psalters include a CALENDAR, Old and New Testament canticles, a LITANY OF SAINTS, and prayers. Psalters designed for use in the celebration of the DIVINE OFFICE might contain other relevant texts, such as antiphons to the Psalms, sometimes with music notation, and the Hours of the Virgin.

The psalter was the principal book for Christian private devotion before the emergence of the BOOK OF HOURS in the thirteenth century. In the Roman LITURGY of the Middle Ages, all 150 Psalms were recited each week in the Divine Office, the majority at matins and vespers. In nonmonastic use, the cycle began at matins on Sunday with Psalm 1 and continued at matins on the following days: Psalm 26 was the first recited on Monday, Psalm 38 the first on Tuesday, Psalm 52 the first on Wednesday, Psalm 68 the first on Thursday, Psalm 80 the first on Friday, Psalm 97 the first on Saturday. The cycle for vespers commenced on Sunday with Psalm 109 and continued throughout

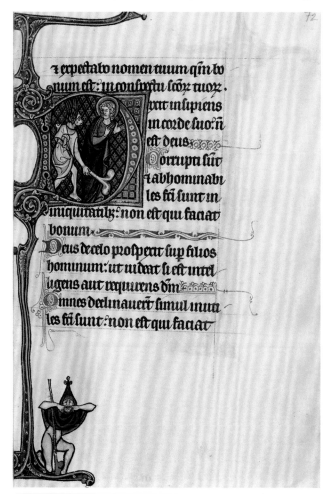

PSALTER

Bute Master, initial *D: The Fool, with a Dog Face and Wearing Winged Headgear, Menacing Christ;* bas-de-page scene *A Fool Making a Face at the Reader.* In a psalter known as the Bute Psalter, northeastern France, ca. 1285. 17 × 11.9 cm (6¹¹⁄₁₆ × 4¹¹⁄₁₆ in.). Los Angeles, JPGM, Ms. 46 (92.MK.92), fol. 72

the week with the remaining Psalms (some Psalms were set aside for other hours). Other divisions of the Psalms are occasionally found, such as the Irish division of the three fifties (beginning at Psalms 1, 51, and 101). These divisions were often given prominence within the decorative program of medieval manuscript psalters.

Depictions of King David, purported author of many of the Psalms, frequently introduce the psalter (especially in HISTORIATED INITIALS to Psalm 1), and PREFATORY CYCLES were often included.

PUMICE

Volcanic glass, used in its powdered form as POUNCE (an abrasive to smooth the surface of PARCHMENT). In its solid form, pumice was employed to scrape parchment for reuse, creating a PALIMPSEST.

PURPLE PAGES

Sheets of PARCHMENT that have been either vat-dyed or painted with an organic colorant to stain them purple. Often used as a dark background for ILLUMINATION or for gold or silver text (see CHRYSOGRAPHY), purple pages were introduced into luxury book production in LATE ANTIQUITY and the EARLY CHRISTIAN period. Important INSULAR, ANGLO-SAXON, CAROLINGIAN, and OTTONIAN liturgical manuscripts employed purple pages, and the aesthetic was revived during the RENAISSANCE. Purple pages in medieval manuscripts were often believed to have been dyed or painted with the ancient Mediterranean murex purple, but modern scientific analysis has demonstrated that most were dyed with less costly red and blue colorants such as orchil (made from lichen), woad, and other more readily accessible organic materials.

PURPLE PAGES
Text page. Detached leaves from a Gospel lectionary, Rhine-Meuse region, ca. early ninth century. 24.1 × 18.1 cm (9½ × 7⅛ in.). Los Angeles, JPGM, Ms. Ludwig IV 1 (83.MD.73), fol. 2v

The surface of this page is dyed purple, appropriate for a book made for a member of Charlemagne's family. The frame and writing are entirely in silver.

Putto (pl. putti)

A nude infant, usually depicted with wings, popular in RENAISSANCE art. See the illustration accompanying WHITE VINE-STEM.

Quarto

The size designation of a medium-size volume, one-quarter the area of a full sheet of writing material.

Quill pen

Pen formed of the flight feather (one of the first five feathers) of the wing of a bird, often a goose, favored for its strength and flexibility and suitable for writing and drawing, from the Latin *penna*, meaning "feather." The quill pen was the writing implement of choice for the medieval scribe, since it was well suited for inscribing text on PARCHMENT. The pen's writing tip, called a *nib*, was cut with a pen KNIFE. The angle of the cuts at the nib and the angle at which the pen was held in the hand affect the appearance of the SCRIPT produced. *Cursive* (i.e., more rapidly written) scripts were generally produced with a thin pen, and formal book scripts with a broad-edged pen. A nib cut at a right angle to the shaft produces an informal, slanted-pen script in which the heads of letter strokes appear slanted, while a nib cut at an oblique angle to the shaft produces a formal, straight-pen script that has horizontal heads to the letter strokes.

Quire See GATHERING.

Raman spectroscopy

An analytical technique that employs laser light to measure the vibrational modes of the chemical bonds of a compound, such as those comprising PIGMENTS, INKS, and BINDING MEDIA used in ILLUMINATION. The coupling of a Raman spectrometer and a microscope (often called *Raman microspectroscopy* or *Raman microscopy*) allows for the analysis of particles as small as a few micrometers in diameter, such as individual pigment grains. The application of Raman spectroscopy to manuscript illumination can identify many pigments and often reveals the use of complex mixtures within paint layers. Raman spectroscopy is particularly well suited to the identification of historical mineral and inorganic pigments. It may be able to identify some organic materials (dyes or binders), depending on the laser wavelength of the instrument employed.

Recto

The front side of a FOLIO or leaf, the side to which the reader goes first when reading a text in natural sequence, from the Latin *regere*, meaning "to lead straight." *Recto* is often abbreviated as *r* and sometimes denoted as *a*. Compare VERSO.

Reflectance spectroscopy

An analytical technique that measures the relative reflectance of light by a material over a range of wavelengths, typically covering the ultraviolet (UV), visible, and the

near-infrared (NIR) parts of the electromagnetic spectrum. When the light is delivered by fiber optics, the technique is known as fiber optic reflectance spectroscopy (FORS). FORS allows small areas to be selectively and noninvasively examined. This technique can identify PIGMENTS or colorants that have sufficiently distinct reflection spectra. Reflectance spectroscopy is particularly informative for distinguishing certain pigments, including ultramarine, indigo, carbon, and some organic dyes (e.g., madder, cochineal, and kermes) that are challenging to identify with other available in situ analysis techniques. In many cases, however, reflectance data alone may not be sufficient to identify pigments conclusively, although they can provide supporting information that, in conjunction with other analyses, may clarify the materials present.

REGISTER

A horizontal tier. MINIATURES containing more than one scene were sometimes divided into registers.

REGISTER

The Battle of Liegnitz; The Beheading of Heinrich and His Soul Carried by Angels to Heaven. In *Vita beatae Hedwigis,* Silesia, 1353. 34.1 × 24.8 cm (13⁷⁄₁₆ × 9¾ in.). Los Angeles, JPGM, Ms. Ludwig XI 7 (83.MN.126), fol. IIV

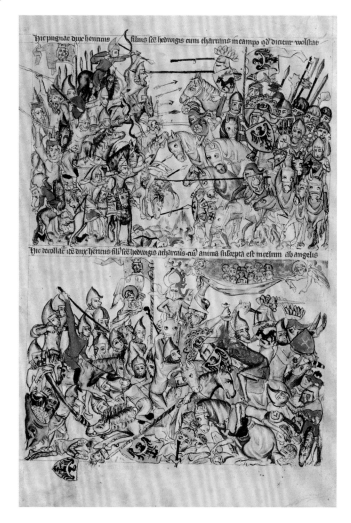

Renaissance

A revival of the arts and learning stimulated by an interest in the past, borrowing the French, meaning "rebirth." Although scholars sometimes speak of the CAROLINGIAN, Northumbrian, and twelfth-century renaissances, the term by itself, capitalized, denotes a two-hundred-year period, from approximately the mid-fourteenth to the mid-sixteenth century, that marks a transition from the Middle Ages to the modern era and is characterized by the revival of the learning of classical ANTIQUITY. *Renaissance* (originally the Italian *rinascimento*) was coined by the Italian HUMANISTS, who saw their own age as significantly different from the preceding one, which they perceived as a "middle age." Working initially in urban centers, including Florence and Rome, the humanists studied CLASSICAL TEXTS, although many of the copies available to them dated no earlier than Carolingian times. The art of the period reveals a concern for NATURALISTIC rendering and the use of classical motifs.

A love of decoration was a feature of Renaissance ILLUMINATION, with the GROTESQUES of GOTHIC art replaced by PUTTI, classical masks, vases, jewels, and other motifs. MINIATURES often reflected the advanced styles of easel and fresco painters (the famous sixteenth-century ILLUMINATOR Giulio Clovio was known as "the little Michelangelo"). Humanist scholars such as Petrarch (1304–1374) and Poggio Bracciolini (1380–1459) were themselves involved in book production, and their reforms of SCRIPT and promotion of literacy played an important role in the early development of printing. Secular patronage was a significant factor in Renaissance book production, with kings, princes, and other nobles throughout Europe using the arts to promote their political and economic status.

RINCEAUX
Decorated text page. In a book of hours, Paris, ca. 1420. 20.2 × 14.9 cm (7¹⁵⁄₁₆ × 5⅞ in.). Los Angeles, JPGM, Ms. 57 (94.ML.26), fol. 43 and detail

RINCEAUX

A form of ornament commonly used in BORDERS during the fourteenth and fifteenth centuries, especially in French manuscripts. It consists of a patterning of fine vines with ivy leaves.

RITUAL

A book containing the prayers and formulas for the administration of sacraments (except the Eucharist) not performed by a bishop, such as baptism and extreme unction.

ROLL

The principal vehicle for writing during ANTIQUITY. The roll (*rotulus* or *volumen*) was formed of sheets of PAPYRUS pasted together. It was unrolled horizontally from left to right, with about four columns of text visible at any one time. Information concerning author, text, and production (the COLOPHON) served to label the roll, along with the INCIPIT and EXPLICIT inscriptions. Although the CODEX largely replaced the roll as the preferred form for the dissemination of literary texts by the fourth century, the roll survived throughout the Middle Ages, fulfilling certain specialized functions. At this time it was generally made of PARCHMENT (sewn or glued together) and was read vertically. Rolls were useful for storing lengthy records and thus were frequently used for administrative purposes (such as Exchequer rolls). They also carried genealogies and pedigrees, and some of these manuscripts were finely illuminated. Roll CHRONICLES often accompanied royal genealogies. Illuminated Exultet rolls, with texts for the blessing of the Easter candle, were designed for public viewing, with the text facing the reader and the images placed upside down in relation to the text, to face the congregation over the lectern. Prayer rolls, including *Arma Christi* rolls, also survive.

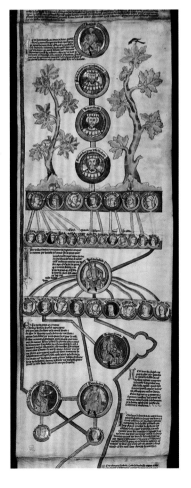

ROLL
Roll including roundels of Harold, the line of the Dukes of Normandy, ancestors of William the Conqueror, and the descendants of William the Conqueror down to Henry I. *Genealogical Roll of the Kings of England*, southern England, first quarter of the fourteenth century (before 1308). 475 × 27.5 cm (147⅝ × 10⅞ in.). London, The British Library, Ms. Royal 14 B vi, Membrane 5

ROMANCE

A genre of literature that developed in the twelfth and thirteenth centuries in France. The Old French word *romanz* originally denoted texts in the French VERNACULAR but later came to be applied to narrative tales of the deeds of noblemen and noblewomen. Romances could be illustrated, sometimes modestly, but often lavishly if the PATRON was wealthy. The combination of imaginative stories of chivalric love and heroism with details from everyday courtly life (which abound in the illustrations) contributed to the popularity of the romance, as did the rise in secular literacy and patronage.

Many examples of the romance can be termed *romans courtois* ("courtly romances"). Early romances are generally in verse, but prose romances (such as the French Arthurian cycle) also proliferated. Among the earliest romances are those written in the late twelfth century by Chrétien de Troyes, who transformed mere incident into meaningful action by stressing moral themes, as in *Erec et Enide*, one of his first works in the genre. Love—as perceived in a rigid system of chivalric behavior—often plays a role in French works, one of the most popular being the *Roman de la rose*, begun by Guillaume de Lorris (ca. 1237) and completed by Jean de Meun (ca. 1275), which combines the allegorical and satirical with courtly love and human emotions. Although fictional, romances were often based on historical events, either classical (e.g., *Kyng Alisaunder*, of the fourteenth century, in Middle English) or medieval (e.g., Sir Thomas Malory's *Le Morte d'Arthur*, of the fifteenth century, also in Middle English).

ROMANESQUE
Saint John the Evangelist.
In a Gospel book,
Helmarshausen, ca.
1120–40. 22.9 × 16.5 cm
(9 × 6½ in.). Los Angeles,
JPGM, Ms. Ludwig II 3
(83.MB.67), fol. 127v

Romanesque

The term applied in the nineteenth century to Western architecture of the late eleventh and early twelfth centuries (the precise span varies from region to region) because of its use of Roman principles of construction. It is generally used to designate manuscript ILLUMINATION of the twelfth century. Although there are regional flavors within Romanesque art, it was essentially an international style. The number of subjects depicted in religious art during this period increased, resulting in an expanded Old and New Testament ICONOGRAPHY (with marked development in TYPOLOGY).

Roman numerals

The system of representing numbers generally employed in Roman ANTIQUITY and the Middle Ages, in which quantities are represented as Roman letters: *I* or *i* (1), *V* or *v* (5), *X* or *x* (10), *L* or *l* (50), *C* or *c* (100), *D* or *d* (500), *M* or *m* (1000). Compare ARABIC NUMERALS.

Rubric

A title or chapter heading that is not strictly part of the text but helps to identify its components. Some rubrics provide INSTRUCTIONS, especially for ceremonial actions prescribed to accompany the recitation of Christian LITURGICAL texts. Red INK was often used to distinguish such elements, hence the term, which derives from the Latin *rubrica*, meaning "red earth."

RUBRIC
Lieven van Lathem, initial *A: Gillion and Marie Gazing at a Mother Carp and Her Offspring.* In *Roman de Gillion de Trazegnies*, Antwerp, after 1464. 37 × 25.5 cm (14⁹⁄₁₆ × 10¹⁄₁₆ in.). Los Angeles, JPGM, Ms. 111 (2013.46), fol. 11v (detail)

In this manuscript, each section of text is preceded by a long descriptive rubric written in red.

Rubricator

A person responsible for supplying the rubrics within a manuscript. Rubrication—often done by a project supervisor or by the SCRIBE of the main text—generally followed the laying out and writing of the text.

Ruling

The process by which framing lines and (often) evenly spaced horizontal lines are drawn on a page to guide the SCRIBE in writing; also refers to the linear guides thus produced. The interval between the ruled lines was customarily guided by PRICKING.

In early medieval manuscripts, ruling was generally executed with a STYLUS (see also HARD POINT), producing incised linear indentations on one side of the FOLIO, with a ridge on the opposite side. If done too vigorously, ruling in hard point could result in splits and tears in the PARCHMENT or paper support. Around 1100, LEAD POINT began to be used more frequently for ruling. By the late thirteenth century, ruling in INK with a QUILL PEN had become the norm. The Italian HUMANISTS revived the use of hard point for ruling to emulate CAROLINGIAN ruling practice. In the fifteenth and sixteenth centuries, colored inks were often employed for ruling private devotional books. See also MISE-EN-PAGE.

RULING
Ruling. In a missal,
Westphalia, ca. 1500–1505.
38.7 × 27.9 cm (15¼ × 11 in.).
Los Angeles, JPGM, Ms. 18
(86.MG.480), fol. 250v

RUNNING TITLE

A line of text at the head of a page (or a pair of pages across an opening) that identifies a work or one of its subsections. Running titles (also called *running heads*) help the reader find the different parts of a manuscript. See the illustration accompanying BIBLE HISTORIALE.

RUN-OVER SYMBOL

A decorative device (usually abstract or foliate, and rarely zoomorphic or anthropomorphic) that indicates that the text of a line has been carried over to occupy the remainder of the line above or below, a space that otherwise would have been left blank. Run-over symbols serve both decorative and space-saving functions, especially in verse forms such as the Psalms.

SACRAMENTARY

A Christian SERVICE BOOK containing the prayers recited by the celebrant during high MASS (collect, secret, postcommunion, and the canon of the mass). The other texts, spoken (or intoned) and sung, of the mass are contained in the GOSPEL LECTIONARY,

the EPISTOLARY, and the GRADUAL. The texts of the sacramentary are divided into the unchanging elements (the canon and ordinary of the mass) and the variable texts, the latter arranged according to the liturgical year into the TEMPORALE and SANCTORALE, customarily followed by the COMMON OF SAINTS and votive masses for special occasions, such as marriage. The CANON PAGE and the *Vere dignum* monogram were the principal forms of ILLUMINATION.

In the early Middle Ages, several distinct rites were current in the West, including the Roman, the Ambrosian of Milan, the Mozarabic of the Iberian Peninsula, and the Gallican of ancient Gaul and neighboring territories. As part of his efforts to standardize church ritual in the CAROLINGIAN period, Charlemagne asked Pope Hadrian I to provide an authentic Roman sacramentary for use throughout the empire. The pope sent the emperor a sacramentary ca. 790 known as the *Sacramentarium Hadrianum*. This was a book reflecting the Roman liturgy for papal use. A supplement was soon added to adapt it to general use. By the late thirteenth century, the sacramentary had been virtually replaced by the MISSAL. See the illustration accompanying INCIPIT PAGE.

SAINTS' LIVES

Narratives of the lives (*vitae*) of Christian saints. In western Europe, the earliest were composed in Latin. As more holy figures came to be considered saints, whether by tradition or through the official process of canonization, in the course of the Middle Ages, new lives were composed in Latin and in the VERNACULAR. Excerpts from the Latin lives were incorporated into the MARTYROLOGY for use as readings in the DIVINE OFFICE. Hagiography (the biography of saints) formed an essential part of the ecclesiastical library and was also a popular source for reading among the LAITY.

SAINTS' LIVES
Anovelo da Imbonate or his circle, *Aimo and Vermondo Chased up Two Trees by Four Wild Boars and Appealing to the Virgin and Child and Saint Victor to Save Them*. In *Legenda venerabilium Aymonis et Vermondi*, Milan, ca. 1400. 25.6 × 18.4 cm (10¹⁄₁₆ × 7¼ in.). Los Angeles, JPGM, Ms. 26 (87.MN.33), fol. 3v (detail)

Sanctorale

The section of a liturgical manuscript that contains formularies (series of prayers and/or chants for a given feast day) for the celebration of saints' feasts, except for those celebrated immediately after Christmas. Because the saints' feasts falling in late December (Saints Stephen and John the Evangelist on December 26 and 27, respectively) were so closely identified with the Christmas season, they were included in the TEMPORALE, usually a separate section in medieval liturgical manuscripts. Compare COMMON OF SAINTS.

School book

A book made for use in teaching within an ecclesiastical or university context. School books can be identified from annotations and other markings made for study purposes. Their production increased greatly with the rise of universities around 1200. STATIONERS emerged as the chief purveyors of school books, which were often (but not necessarily) quite modestly and cheaply produced, sometimes using the PECIA SYSTEM. The subjects of medieval school books include COMMENTARIES on Scripture and PATRISTIC TEXTS, as well as treatises on grammar, mathematics, and astronomy; legal texts (see DECRETALS and DIGEST); MEDICAL TEXTS; and CLASSICAL TEXTS.

School of illumination

A term of convenience for a group of artists whose work is stylistically related. The decoration of a given manuscript is often attributed to a school of illumination. Not a school or academy in the modern sense, a school of illumination is most commonly named after a place where the works were produced (e.g., the Ghent-Bruges School).

Scribe

A person engaged in the physical writing of books or documents. A number of scribes were also artists. In ANTIQUITY, scribes and notaries constituted a professional class. In the Middle Ages, scribes often worked within an ecclesiastical SCRIPTORIUM as part of a team or were attached to a court or an official chancery (a record office). Following the rise of the universities around 1200, scribes were increasingly found in urban settings, living alongside one another, although the monastic production of books continued and some scribes found places in the households of princes and kings. Both men and women served as scribes, and occasionally authors were themselves competent scribes (e.g., Petrarch and Christine de Pizan in the fourteenth and early fifteenth centuries, respectively). Scribes sometimes employed assistants. See also MONASTIC PRODUCTION and SECULAR PRODUCTION. See the illustration accompanying EVANGELIST PORTRAIT.

Script

The handwriting used in manuscripts. Medieval script was subject to greater discipline and more rigid rules and hierarchies than modern personal handwriting, for in premodern book production handwriting had to serve many of the functions of modern print. The form and function of a book determined the overall appearance of a script—its *aspect*—and the number of space-saving devices employed (notably ABBREVIATIONS). The cut and thickness of the pen nib can affect the appearance and degree of formality

SCRIPT

Joris Hoefnagel, *Centipede, Wood Cranesbill, and Mushroom.* In *Mira calligraphiae monumenta*, Vienna, 1561–96. 16.6 × 12.4 cm (6⁹/₁₆ × 4⁷/₈ in.). Los Angeles, JPGM, Ms. 20 (86.MV.527), fol. 44

Georg Bocskay is responsible for the writing in this model book of calligraphy, originally created for the Holy Roman emperor Ferdinand I. Some thirty years later the pages were illuminated by Joris Hoefnagel for Ferdinand's grandson, Rudolf II.

of a script (see QUILL PEN). Majuscule scripts employ what are the equivalent of printed uppercase letters and are generally of even height. This script is sometimes termed *bilinear*, the height of letters being determined by two imagined horizontal lines, the baseline and the headline. Minuscule scripts are composed of the equivalent of printed lowercase letters, with longer strokes (ascenders and descenders) that extend above and below the body of the letter (as in *d* and *q*) and touch on four imagined lines (*quadrilinear* or *quattrolinear* script).

In LATE ANTIQUITY, majuscule scripts, including square and rustic capitals and uncials, were used for most literary texts. The development of Caroline minuscule (see CAROLINGIAN) in the late eighth century led to the predominance of minuscule for the writing of books. The degree of formality now lay in the speed and care with which a script was written. The more deliberately written text scripts of the high Middle Ages are generally termed *textualis* or *textura*, while the less formal are sometimes termed *cursives.* The fusion of the formal and cursive styles gave rise to *hybrid* or *bastard* scripts.

Beginning around 1400, the HUMANISTS sought to reform medieval scripts, and their new scripts laid the foundation for many early typefaces.

Scriptorium (pl. scriptoria)

A writing room. The term is generally (but not exclusively) used for the place in a monastery where books are made.

Secular production

Some book production was always a secular activity in the Middle Ages, with SCRIBES working at royal courts and in households. Before the rise of the universities around 1200, however, most books were produced in ecclesiastical SCRIPTORIA, although secular itinerant artists probably participated at times in MONASTIC PRODUCTION. With the growth of more commercialized book production after 1200, scribes, ILLUMINATORS, and the STATIONERS who might supply their materials and subcontracted work were usually members of the LAITY—both men and women—although some might be clerics in minor orders. Scribes, illuminators, stationers, and PARCHMENTERS often lived in the same urban neighborhood and necessarily worked together on projects. Throughout the period, aristocrats participated in book production as PATRONS and as authors, some of them (such as Christine de Pizan in the early fifteenth century) actually copying their own works, a trend that flourished among HUMANIST authors.

Secundo folio

The opening words of the second leaf of a manuscript, from the Latin *secundus*, meaning "following." Since these words differ from one manuscript copy of a text to another, the secundo folio is often cited when cataloging manuscripts, a practice that originated in the Middle Ages to distinguish individual copies of a text in a way that its opening words could not.

Sequentiary

A book (or portion of a GRADUAL or TROPER) containing *sequences*, chants that embellish the Alleluia at MASS.

Service book

A book used in the celebration of a Christian religious ritual.

Sewing on supports

The process of linking the GATHERINGS of a manuscript in sequential order during BINDING by sewing them onto supporting BANDS made of a strong, flexible material, usually CORDS, THONGS of ALUM-TAWED SKIN or leather, or tapes of woven textile or PARCHMENT. Western medieval bindings were typically sewn on raised supports, which can be either single or doubled, creating raised ridges at each of the SEWING STATIONS. In the late sixteenth century, single cords were often worked into saw cuts at each sewing station (called *recessed cord sewing*) to achieve a flat SPINE.

Sewing stations

The positions at which the sewing needle and thread travel through holes or cuts in the SPINE fold to sew the GATHERINGS, either by linking one gathering to another directly (see COPTIC SEWING) or by looping the thread around BANDS (see SEWING ON SUPPORTS).

Sgraffito

The technique of scratching through a layer of paint to reveal an underlying layer of paint or the writing surface, from the Italian *graffiare*, meaning "to scratch."

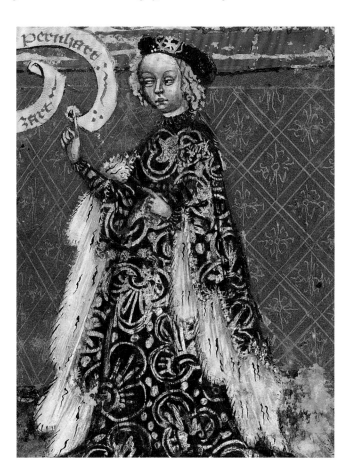

SGRAFFITO
A Scribe and a Woman.
In Rudolf von Ems,
Weltchronik, Regensburg,
ca. 1400–1410. 33.5 × 23.5
cm (13³⁄₁₆ × 9¼ in.). Los
Angeles, JPGM, Ms. 33
(88.MP.70), fol. 3 (detail)

In this miniature, the illuminator has scratched through the blue paint to create a design in the background.

Shelf mark

A mark, often incorporating a number, that indicates a book's location within a library. The shelf mark is frequently the designation by which an individual manuscript is known.

SHOULDER

The position on a BINDING where a BOARD meets the SPINE along which the cover is able to flex away from the textblock. Shoulders are created by the rounding of the spine, either formed by bevels on the inner edge of the board or imposed by direct hammering and shaping of the spine folds of the GATHERINGS. The shape is held secure by pasted or glued linings.

SIGNE-DE-RENVOI

A graphic symbol, also called a *tie mark*, indicating a place where a CORRECTION or insertion is to be made, as well as a corresponding symbol, usually written in the margin, introducing the corrected text or insertion. The term is borrowed from the French meaning "sign of return."

SIGNE-DE-RENVOI
Signe-de-renvoi. In the *Vidal Mayor*, northeastern Spain, ca. 1290–1310. Los Angeles, JPGM, Ms. Ludwig XIV 6 (83.MQ.165), fol. 12v

SINGLETON

A half of a BIFOLIUM that has lost its mate, often identifiable by a stub that can be seen where its CONJOINT leaf would have been. A singleton can also be a leaf that originally was designed to be sewn into a book as a half sheet.

SINGLETON
Text pages with stub. In a Gospel book, Lorsch, ca. 826–38. 31.6 × 24 cm (12⁷⁄₁₆ × 9⁷⁄₁₆ in.). Los Angeles, JPGM, Ms. Ludwig II 1 (83.MB.65), fols. 15v–16 (detail)

A parchment stub visible along the length of the spine fold reveals the presence of a singleton in this gathering.

SPINE

The edge at which the GATHERINGS of a CODEX are sewn together. Medieval spines were flat, except for the raised BANDS. Rounded, glued spines that were hammered into shape were first introduced in the early sixteenth century. Spines sometimes carry protective extensions at the HEAD and TAIL known as *end tabs*.

STAMPING See TOOLING.

STATIONER

A middleman coordinating the production of books in an urban setting. Stationers emerged following the rise of the universities around 1200, as the growth in SECULAR PRODUCTION and in consumer demand led to increasing specialization and commercialization in book production. Stationers were called *cartolai* in Italy and *libraires* in France. They sometimes worked with the formal recognition of a university. See also PECIA SYSTEM.

STEMMA (PL. STEMMATA)

A diagram representing the transmission of a text or program of ILLUMINATION that indicates relationships between surviving manuscripts and the existence of possible lost originating and intermediary EXEMPLARS.

STRAP AND PIN

A two-part device for keeping a book closed, consisting of a small metal plate with a raised pin placed at or near the center of one of the BOARDS and a leather strap attached to the opposite board. The end of the strap was often furnished with a

STRAP AND PIN
Front cover. Peter Comestor, *Historia scholastica*, Austria, ca. 1300. Los Angeles, JPGM, Ms. Ludwig XIII 1 (83.MP.144) (detail)

Shaped like dogs' heads, the metal fittings at the ends of the straps on this manuscript ensure a tight closure of the binding when secured onto the corresponding protruding pins.

pierced metal tab at its end, designed to slot onto the corresponding pin. Often used singly or in pairs on ROMANESQUE bindings of the twelfth and thirteenth centuries (including CHEMISE BINDINGS), variants on strap-and-pin closures are found on early medieval CODICES, such as the toggle and loop on COPTIC bindings of the ninth century and the strap and fore-edge peg on CAROLINGIAN bindings. The position of the pin on the front or back cover is often seen as reflecting regional practice. See also CLASP AND CATCH.

STYLIZED

A rendering of a painted subject that is governed by nonnaturalistic decorative concerns, which may be EXPRESSIONISTIC.

STYLUS (PL. STYLI)

A pointed implement, generally of metal or bone, that is used for writing on wax TABLETS and might be used for PRICKING and RULING a manuscript. Some styli have flat triangular heads that, when heated, were used to smooth wax in tablets for reuse.

SUFFRAGE

An intercessory prayer, sometimes called a *memorial*, addressed to a saint. A suffrage is preceded by an antiphon, a versicle, and a response, and may occur during the DIVINE OFFICE. Suffrages of saints were often included in BOOKS OF HOURS, where they were presented according to a hierarchy, beginning with the Trinity and often followed by the Virgin, Saint Michael, Saint John the Baptist, the apostles, martyrs, confessors, and female saints. The particular saints appearing in a group of suffrages vary according to region or personal devotions.

TABLET

A flat slab of wood, or sometimes ivory, used as a writing surface in two ways: either INK was applied on it or it was hollowed out and filled with wax so that one could write with a STYLUS. The tablet was used in ANTIQUITY for informal writing and for some record keeping. The substitution of sheets of PARCHMENT for wood or ivory may well have stimulated the development of the CODEX form. During the Middle Ages, tablets were used for a variety of functions: drafting texts, trying out artistic designs, recording liturgical commemorations, taking notes during study, and in accounting and legal contexts. Although different colors of wax were used, black and green predominated. A number of tablets were sometimes bound together with leather thongs or within a leather case. Tablets were also made with a pair of handles (the *tabula ansata*), whose shape could serve as a decorative motif.

TAIL

The foot or lower end of a manuscript.

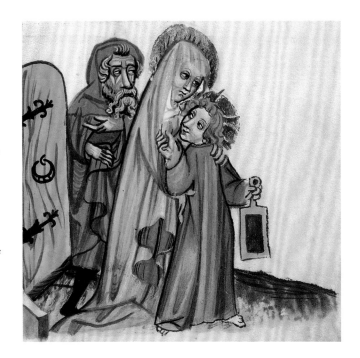

TABLET
Jesus among the Doctors.
In Rudolf von Ems,
Weltchronik, Regensburg,
ca. 1400–1410. 33.5 ×
23.5 cm (13³⁄₁₆ × 9¼ in.).
Los Angeles, JPGM, Ms.
33 (88.MP.70), fol. 261
(detail)

This detail shows the
twelve-year-old Jesus
holding a wax tablet as he
and his parents leave the
Temple in Jerusalem.

TAILPIECE

A panel of ornament, sometimes containing text, that stands at the end of a text. See also HEADPIECE.

TANNING

The process of manufacturing leather by soaking animal skin in vegetable tannin, an acidic and astringent solution (called a tanning *liquor*) made from tree bark, OAK GALL, or a similar organic material. Tanning converts the raw animal hide by consolidating the dermal fibers of the skin, giving the resulting leather internally cohesive strength as well as resistance to water and heat. Tanning also can give the skin a rich brown coloration, depending upon the tanning liquors and dyes used.

TE IGITUR PAGE See CANON PAGE.

TEMPORALE

The section of a Christian liturgical book containing the formularies (series of prayers and/or chants for a given feast day) for Christological feasts (including Christmas, Easter, the Ascension, and Pentecost) and the Sundays of the year. The temporale also includes the saints' feast days celebrated in late December (Saints Stephen and John the Evangelist) because of their close association with the Christmas season. Compare SANCTORALE.

TEXTILE CURTAIN

Initial *E: The Death of Moses*. In a Bible known as the Marquette Bible, France, probably Lille, ca. 1270. 47 × 30.8 cm (18½ × 12⅛ in.). Los Angeles, JPGM, Ms. Ludwig I 8 (83.MA.57), vol. 1, fol. 50

TEXTILE CURTAIN

A piece of woven textile sewn to an illuminated FOLIO (or its facing folio) to act as a protective interleaving for a painted MINIATURE or INITIAL. Usually made of silk, linen, or cotton gauze (dyed or undyed), the textile curtain is attached by a thread stitched through the PARCHMENT. The medieval addition of sewn-in textile interleaving curtains may have been related to the practice of veiling liturgical vessels and sacred icons, as the lifting of the curtain would impart a revelatory experience to the reader of the manuscript. Textile curtains were frequently removed by later book owners, leaving behind a series of small holes piercing the parchment adjacent to an illumination and the occasional remnant of the attachment thread or threads.

THONGS

Narrow strips of ALUM-TAWED SKIN or leather onto which the gatherings are sewn (see SEWING ON SUPPORTS). A thong might be split to allow for a figure-eight sewing around and through the thong at each SEWING STATION. The free ends of the thongs were then laced into tunnels or channels in the BOARDS to securely attach the sewn textblock to them. See also CHANNELING, CORDS, and PEGGING.

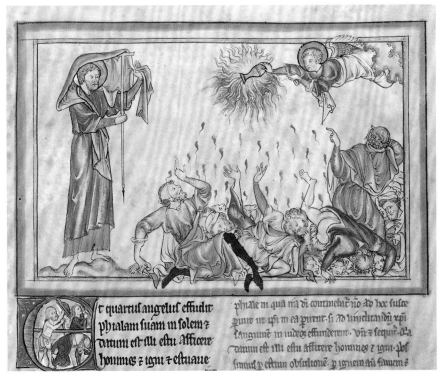

TINTED DRAWING

The Fourth Vessel: The Sun's Heat Burning Humanity. In an Apocalypse known as the Getty Apocalypse, England, probably London, ca. 1255–60. 31.9 × 22.5 cm (12⁹⁄16 × 8⅞ in.). Los Angeles, JPGM, Ms. Ludwig III 1 (83.MC.72), fol. 33 (detail)

TINTED DRAWING

A style of ILLUMINATION in which the outlines of the subject are drawn in black or colored INK and tints of colored wash are applied to all or some of the surfaces to suggest modeling. Tinted drawing was particularly popular in ANGLO-SAXON England and enjoyed a revival in thirteenth-century England in the work of Matthew Paris. The technique is sometimes used in conjunction with FULLY PAINTED elements. Compare OUTLINE DRAWING.

TIRONIAN See ABBREVIATION.

TITLE PIECE

A decorative panel or page carrying the title of a work.

TONARY

A book or a section of a book in which antiphons, responsories, and other chants of the MASS and DIVINE OFFICE are classified according to the eight musical modes.

TOOLING

Front cover. *Chronicle of the Hohenzollern Family*, Augsburg and Rottenburg, ca. 1572. 36.5 × 29.2 × 2.3 cm (14⅜ × 11½ × ⅞ in.). Los Angeles, JPGM, Ms. Ludwig XIII 11 (83.MP.154)

The decorative treatment of this binding combines gold and blind tooling with a repeated panel-stamped design at the center.

TOOLING

The method of decorating the surface of a BINDING with impressed designs made with the aid of metal hand tools. The term is also used to describe the overall design made by this technique. Carved metal tools (called *finishing tools*) used for this purpose include brass lettering, single design punches, carved rolls (that impart a repeated design), fillet rolls, and palette tools (for continuous or repeated lines). The metal tools are heated and impressed into the covering material (typically dampened leather or ALUM-TAWED SKIN) adhered to the BOARDS. The impression or indentation produced is called BLIND TOOLING if it remains uncolored and ungilded. Gold tooling on bindings became a frequent decorative technique in the fifteenth century and after. In this process, a blind-tooled design was coated with GLAIR, and gold leaf was laid over the design and impressed again with the same heated tool into the leather, leaving an image in gold after the excess was rubbed away. For the tooling of gold leaf in ILLUMINATION, see GILDING.

TRANSITIONAL STYLE

A style practiced in European painting from about 1180 to 1220, that is, in the period of transition between the ROMANESQUE and the GOTHIC. The most notable characteristic of this art is its stylistic experimentation, stimulated partly by a heightened interest in BYZANTINE art. The Transitional Style shows a shift toward more NATURALISTIC treatment of the human figure and drapery.

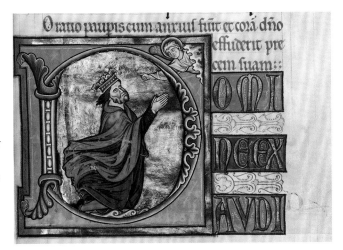

TRANSITIONAL STYLE
Master of the Ingeborg
Psalter, initial *D: David in
Prayer*. In a psalter, probably
Noyon, after 1205. 31 × 21.9
cm (12³⁄₁₆ × 8⅝ in.).
Los Angeles, JPGM, Ms. 66
(99.MK.48), fol. 108 (detail)

TREASURE BINDING

A BINDING in which the BOARDS are adorned with precious metals, jewels, textiles,
and/or sculpted plaques (in metal, ivory, or enamel). Meant to enshrine a sacred text,
treasure bindings are typically found on Christian SERVICE BOOKS and on private
devotional manuscripts belonging to an exceptionally wealthy PATRON. Treasure bind-
ings on liturgical manuscripts might be displayed on the altar along with other sacred
treasures of the Church.

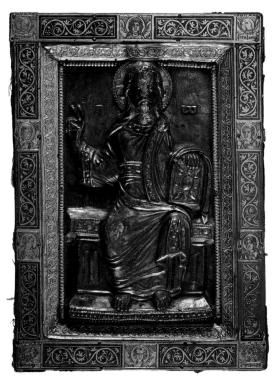

TREASURE BINDING
Front cover. Sacramentary,
Mainz or Fulda, ca. 1025–50.
27.9 × 21.4 × 7 cm (11 ×
8⁷⁄₁₆ × 2¾ in.). Los Angeles,
JPGM, Ms. Ludwig V 2
(83.MF.77)

TROMPE L'OEIL

Georges Trubert, *The Madonna of the Burning Bush*. In a book of hours, Provence, ca. 1480–90. 11.4 × 8.6 cm (4½ × 3⅜ in.). Los Angeles, JPGM, Ms. 48 (93.ML.6), fol. 154

On this page, the illuminator has created the illusion that a framed picture is hanging from a chain that is threaded through a pair of slits in the parchment.

TROMPE L'OEIL

Painting, including manuscript ILLUMINATION, in which things are made to appear to be resting on, projecting from, or piercing through a surface, borrowing the French meaning "deceives the eye."

TROPER

A book, or a section of a book, containing *tropes*, that is, musical and textual additions to the chants of the MASS or DIVINE OFFICE.

TURN-INS

The edges of the covering material of a BINDING, which are folded over the HEAD, TAIL, and FORE EDGES of the BOARDS and secured to their inner surfaces.

TYPOLOGY

A method of Christian scriptural interpretation whereby persons or events in the Old Testament are seen to prefigure persons or events in the New Testament or the history of the Church. The sacrifice of Isaac, for example, foretells the Crucifixion; David is a type of Christ; and the stories of Jonah and the whale and Daniel in the lions' den prefigure Christ's Resurrection. Although encountered during the early Middle Ages, typological juxtapositions become more frequent in art from the eleventh century on. See also BIBLIA PAUPERUM.

Underdrawing

Preliminary drawing that underlies the final painted or inked design. Prior to the eleventh century, underdrawing for ILLUMINATION was often executed with a HARD POINT, but thereafter METALPOINT, especially LEAD POINT, or diluted INK (applied with a pen or BRUSH) was generally used. ILLUMINATORS might also employ a STYLUS, dividers, and compass to lay out a geometric design as part of the underdrawing.

Underdrawing
Rohan Master, *The Rejection of Joachim and Anna's Offering*. Detached leaf from a book of hours, Paris, ca. 1410–30. 26 × 18.5 cm (10¼ × 7⁵⁄₁₆ in.). Los Angeles, JPGM, Ms. 112 (2014.56), recto

Since the painting is unfinished in this illumination, the loosely drawn ink underdrawing remains visible.

Use

A version of the Christian LITURGY practiced in a particular geographic region or by a particular group of people. The rites of the Christian liturgy developed along regional lines beginning in the EARLY CHRISTIAN period (producing, for example, Roman, Ambrosian, Gallican, and Mozarabic rites), although the Roman rite largely came to be regarded as the standard in the West. The texts of the MASS and the DIVINE OFFICE and their ordering throughout the year varied in accordance with these rites. The inclusion of local saints in CALENDARS and LITANIES can provide useful clues as to where a book was made or intended to be used, if not—properly speaking—its use. During the late Middle Ages, some uses were codified by cathedrals or major religious orders (such as the Sarum rite of Salisbury) and subsequently spread beyond

their region of origin. In the sixteenth century, as part of the general spirit of Catholic reform, the Council of Trent (1545–63) formed a commission to establish a more consistent liturgy of the mass for use in Latin Christendom. In Protestant England, the Book of Common Prayer (1549) mandated the observance of one use throughout the realm.

In BOOKS OF HOURS, the Psalm antiphons and the *capitula* for the hours of prime and none (see DIVINE OFFICE) of the Hours of the Virgin are important indications of use. Methods for identifying lesser-known uses continue to be explored.

VADE MECUM

A portable book, often suspended from a belt, from the Latin meaning "goes with me." The book frequently consisted of leaves folded in an accordion or other fold-out arrangement. Such books could be consulted easily by physicians, for example, and often contain CALENDARS, almanacs, and medical information. See also GIRDLE BOOK.

VADE MECUM
A folded almanac (*vade mecum*). Italy, probably Ferrara, ca. 1450–58. Binding: 12.6 × 3.8 × 2.0 cm (5 × 1½ × ¾ in.). San Marino, The Huntington Library, HM 47641

VELLUM See PARCHMENT.

VERE DIGNUM MONOGRAM

See MISSAL and SACRAMENTARY. See the illustration accompanying INCIPIT PAGE.

Vernacular

A regional language, as distinct from an international literary language, such as Latin and Greek. Throughout western Europe in the Middle Ages, texts of a LITURGICAL character were generally in Latin (although biblical texts were eventually translated into the vernacular). The growth of secular literacy beginning in the twelfth century stimulated an increased use of the vernacular for the texts in manuscripts. See also BIBLE.

Verso

The back of a FOLIO or leaf, the side the reader goes to after turning the page when reading the text in natural sequence, from the late Latin *vertere*, meaning "to turn." *Verso* is abbreviated as *v* and sometimes denoted as *b*. Compare RECTO.

Volvelle

A type of slide chart with revolving wheels or circular disks of PARCHMENT or PAPER attached at center points to a FOLIO (or attached to a BOOKMARKER), from the Latin *volvere*, meaning "to turn." Often including pointers, when manipulated a volvelle enabled the reader to make computational, astronomical, calendrical, or astrological determinations based upon the relative positions of various markings.

VOLVELLE
Astronomical table with volvelle. In *Astronomical and Medical Miscellany*, Oxford or Worcester, ca. late fourteenth century. 21.3 × 15.2 cm (8⅜ × 6 in.). Los Angeles, JPGM, Ms. Ludwig XII 7 (83.MO.136), fol. 51

WATERMARK

Watermark. In a tournament book, Augsburg, ca. 1560–70. Los Angeles, JPGM, Ms. Ludwig XV 14 (83.MR.184), fol. 9 (detail)

This watermark in the form of a shield was created by a raised wire profile sewn onto the wire-mesh screen of a paper mold.

WATERMARK

The wire profile design for a watermark is sewn with fine metal wire onto the surface of a re-creation of an antique paper mold. Los Angeles, JPGM, Department of Paper Conservation

WATERMARK

A design formed in PAPER by a metal wire (called a *wire profile*) sewn to the woven wire-mesh screen of a paper mold. During the formation of a sheet of paper, fewer cellulose fibers are deposited along the wire profile in relief, creating a semitransparent design in the paper (visible in raking or transmitted light). An innovation often ascribed to thirteenth-century Italian papermakers, watermarks—like trademarks—can denote the papermaker or paper mill and provide information pertinent to the paper's date and place of ORIGIN. Scholars study watermarks as part of a manuscript's CODICOLOGY.

WHITE VINE-STEM

A style of BORDER developed by Italian HUMANISTS, termed *bianchi girari* in Italian. The motif originated in fifteenth-century Florence and spread throughout Europe, accompanying HUMANIST and CLASSICAL TEXTS. White vine-stem borders were a conscious emulation of Italian manuscripts of the twelfth century, often the earliest surviving manuscripts of classical texts available to the humanists. The white vine was generally left as reserve, or unpainted, parchment.

WHITE VINE-STEM

Ser Ricciardo di Nanni, initial *M: Portrait of Lactantius*. In *Divinae institutions; De ira dei; De opificio dei; De ave phoenice*, Florence, ca. 1456. 32.9 × 22.1 cm (12^{15}⁄₁₆ × 8^{11}⁄₁₆ in.). Los Angeles, JPGM, Ms. Ludwig XI 1 (83.MN.120), fol. 2 and detail

WORKSHOP

A studio in which a number of artists work together, generally under a MASTER, either on a regular or ad hoc basis, also known by the French term *atelier*. The term *workshop* is also used to refer to a group of artists who work together, sometimes denoting in this sense the secular equivalent of the monastic SCRIPTORIUM during the GOTHIC and RENAISSANCE periods (and in ANTIQUITY as well). ILLUMINATORS working on the same project did not necessarily belong to a workshop, since they frequently lived in the same urban neighborhood and might join together for a single commission. In the context of attributing a work of art to a particular artist, the term *workshop product* is used when the art is in the style of a master but is thought to have been executed by an assistant emulating that style. See also SCHOOL OF ILLUMINATION, SECULAR PRODUCTION, and STATIONER.

WRITTEN SPACE See DIMENSIONS.

X-RAY FLUORESCENCE (XRF) SPECTROSCOPY

A technique widely applied to the analysis of works of art that can detect most elements commonly found in metals and in mineral-based and inorganic PIGMENTS. XRF instruments used in situ typically cannot detect light elements such as carbon, nitrogen, and oxygen.

In an analyzed area, the pigments present can often be inferred based on the elements detected (e.g., mercury, lead, arsenic, potassium), the color of the material, and the researcher's knowledge of the most likely candidates to be found on the object given its presumed date and place of manufacture. When XRF is used as an analytical technique for the study of manuscript illumination, trace metallic elements present in the materials of the substrate (parchment, paper, or papyrus) must also be considered. Given the thin paint and ink layers used in manuscript illumination and the thinness of the support, the dual-sided nature of manuscript folios must also be considered when interpreting XRF data, as the materials on the front, reverse, and underlying pages may be detected simultaneously by the penetrating X-rays.

An increasingly used extension of XRF spectroscopy is two-dimensional scanning (*XRF-scanning*), in which thousands of spectra (depending on the instrument used and the area scanned) are collected over a defined area, resulting in a two-dimensional image called an *element map*. A single scan yields maps for all elements detected, enabling the researcher to evaluate the relative distributions of the materials used in an illumination. A key benefit of XRF-scanning is its ability to detect hidden features such as changes to the design, UNDERDRAWINGS, application methods in GILDING, and traces of partially erased features or areas of OVERPAINTING.

X-RAY FLUORESCENCE (XRF) SPECTROSCOPY
Initial *V: The Prophet Micah*. Historiated initial from a Bible, France, ca. 1131–63. 13.7 × 13.5 cm (5⅜ × 5⁵⁄₁₆ in.). Los Angeles, JPGM, Ms. 38 (89.MS.45), recto

Data collected from an X-ray fluorescence scan result in maps for the major elements detected in the inks and pigments used. The iron (Fe) map shows the iron gall ink from both sides of the leaf, particularly helpful for cuttings that might have their reverse obscured. The lead (Pb) map shows the lead-point ruling lines (including those from the opposite side of the leaf) and lead-based pigments. The copper (Cu) map corresponds to the original copper-green pigment, whereas the chromium (Cr) map reveals a modern green pigment used for retouching.

visible	Fe Kα	Pb Lα	Cu Kα	Cr Kα

Xylograph

An image or text printed from wood. In the late fifteenth and sixteenth centuries, xylographs occasionally appeared in manuscripts and were often hand colored.

Zoo-anthropomorphic initial

An INITIAL partly or wholly composed of conflated human and animal forms. Zoo-anthropomorphic EVANGELIST SYMBOLS, in which a human body is surmounted by the head of the symbolic animal, are occasionally found in INSULAR and later art, being particularly popular in Brittany. Zoo-anthropomorphic motifs also occur in other decorative contexts, especially BORDERS.

Zoo-anthropomorphic initial
Initial *I: Saint John as the Eagle*. In a New Testament with the canons of Priscillian, France, probably Pontigny, ca. 1170. 43.5 × 31.4 cm (17⅛ × 12⅜ in.). Los Angeles, JPGM, Ms. Ludwig I 4 (83.MA.53), fol. 78v (detail)

Zoomorphic initial

An INITIAL partly or wholly composed of animal forms. Zoomorphic motifs occur in other decorative contexts as well, especially BORDERS.

Selected Bibliography

Alexander, Jonathan J. G. *Medieval Illuminators and Their Methods of Work*. New Haven: Yale University Press, 1992.

Brown, Michelle P. *The British Library Guide to Writing and Scripts: History and Techniques*. London: The British Library, 1998.

Brown, Michelle P., and Patricia Lovett. *The Historical Source Book for Scribes*. Toronto and London: University of Toronto Press, 1999.

Clarke, Mark. *The Art of All Colours: Mediaeval Recipe Books for Painters and Illuminators*. London: Archetype, 2001.

Clemens, Raymond, and Timothy Graham. *Introduction to Manuscript Studies*. Ithaca, NY, and London: Cornell University Press, 2007.

De Hamel, Christopher. *The British Library Guide to Manuscript Illumination: History and Techniques*. London: The British Library, 2001.

_____. *A History of Illuminated Manuscripts*. 2nd ed. London: Phaidon Press Limited, 2014. First published 1994.

_____. *Making Medieval Manuscripts*. Oxford: Bodleian Library, University of Oxford, 2018. Originally published as *Scribes and Illuminators* by the British Museum in 1992.

Delamare, François, and Bernard Guineau. *Colors: The Story of Dyes and Pigments*. Translated by Sophie Hawkes. New York: Abrams, 2000.

Gettens, Rutherford J., and George L. Stout. *Painting Materials: A Short Encyclopaedia*. New York: Dover Publications, 1966. Corrected republication of the work published by D. Van Nostrand Company in 1942.

Jakobi-Mirwald, Christine, with the assistance of Martin Roland. *Buchmalerei: Terminologie in der Kunstgeschichte*. 4th ed. Berlin: Reimer, 2015.

Knight, Stan. *Historical Scripts: From Classical Times to the Renaissance*. New Castle, DE: Oak Knoll Press, 1998.

Ligatus Research Centre, University of the Arts London. "The Language of Bindings Thesaurus." Accessed August 17, 2017. www.ligatus.org.uk/lob/.

Ostos, Pilar, María Luisa Pardo, and Elena E. Rodríguez. *Vocabulario de Codicología*. Madrid: Acro/Libros, 1997. Revised and expanded edition of Denis Muzerelle, *Vocabulaire codicologique*. Paris: Éditions CEMI, 1985.

Roberts, Matt T., and Don Etherington. *Bookbinding and the Conservation of Books: A Dictionary of Descriptive Terminology*. Washington, DC: Library of Congress, 1982.

Shailor, Barbara A. *The Medieval Book*. Medieval Academy Reprints for Teaching 28. Toronto: University of Toronto, 1991. Originally published by the Beinecke Rare Book and Manuscript Library, Yale University, in 1988.

Whitley, Kathleen P. *The Gilded Page: The History and Technique of Manuscript Gilding*. 2nd ed. New Castle, DE: Oak Knoll Press; London: The British Library, 2010.